IMAGES
of America

MINES AROUND
SILVERTON

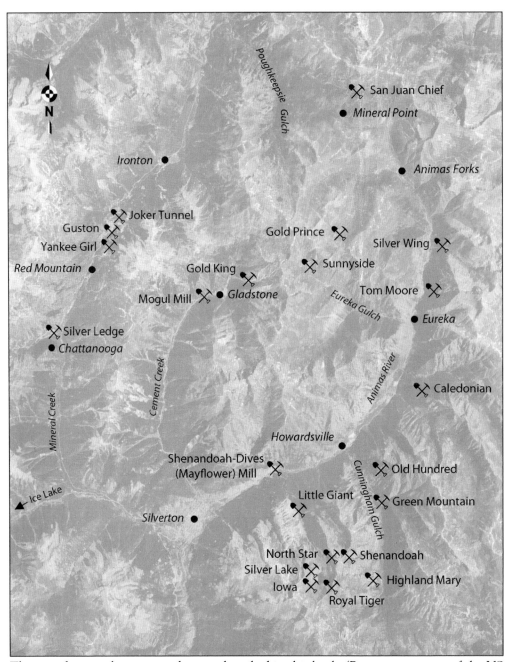

This map features the towns and mines described in this book. (Base map courtesy of the US Geological Survey.)

ON THE COVER: Four men are seen in this winter scene from 1906 standing or sitting on two buckets between the Gold King Mine and the Gold King Mill located in Gladstone. Two tram towers can be seen in the distance. Often the easiest and quickest way to travel to and from the mines, riding these tram buckets was not always the safest way to commute. (Courtesy of the San Juan County Historical Society.)

IMAGES
of America

MINES AROUND
SILVERTON

Karen A. Vendl and Mark A. Vendl with
the San Juan County Historical Society
Introduction by Duane A. Smith

ARCADIA
PUBLISHING

Published by Arcadia Publishing
Charleston, South Carolina

Printed in the United States of America

Library of Congress Control Number: 2015948530

For all general information, please contact Arcadia Publishing:
Telephone 843-853-2070
Fax 843-853-0044
E-mail sales@arcadiapublishing.com
For customer service and orders:
Toll-Free 1-888-313-2665

Visit us on the Internet at www.arcadiapublishing.com

*To Ed and Cherry Hunter, wonderful friends who were
dedicated to the preservation of mining history*

CONTENTS

Acknowledgments 6

Introduction 7

1. Silverton 9

2. Red Mountain 21

3. Las Animas Mining District 31

4. Howardsville 55

5. Gladstone 75

6. Mineral Point 85

7. Animas Forks 93

8. Eureka 105

Bibliography 126

The San Juan County Historical Society 127

ACKNOWLEDGMENTS

We would like to thank the many people who helped us. This book would not have been possible without the enthusiastic assistance of Casey Carroll and Ray Dileo at the Archive Research Center of the San Juan County Historical Society. The San Juan County Historical Society graciously gave us permission to use photographs from their collection in this book. Bill Jones provided identifications of a number of photographs and descriptions of the equipment in the Sunnyside Mill. Coi Drummond-Gehrig of the Denver Public Library has always been very helpful in providing images from the Western History Collection. Melissa VanOtterloo and Jay DiLorenzo of History Colorado provided images from the museum's collection. John Taylor, Tom Rosemeyer, Ed Hunter, and Benjy Keuhling provided photographs from their collections. Stacia Bannerman of Arcadia Publishing was most helpful to us. This book has benefitted from the expert review by Scott Fetchenhier, Bill Jones, Duane Smith, and Zeke Zanoni. Special thanks go to our good friend Duane Smith for writing the introduction.

Unless otherwise noted, all images appear courtesy of the San Juan County Historical Society.

INTRODUCTION

Silverton, Colorado, lies in the heart of the San Juan mining region, one of the state's and the West's major mining districts. The area was first prospected for gold in 1860–1861, but isolation, the Utes' resistance to intrusions on their land, and the ensuing Civil War prevented development for most of the 1860s. As one prospector observed, the altitude was high, the snow "more of a problem," the prospecting season short, and the cost of living nearly as "high as the mountains."

Even as late as February 1874, a newspaper account warned its readers that the country "is wholly without [mining] machinery." It snows from "September through May," with "frosts in July and August." The author did not question that the district contained "immense deposits." It was wholly without settlements, and "all supplies had to be brought in from a long distance." Such remained the lure of gold and silver, of which the San Juans contained both. Prospectors and miners continued to venture into this mining district, one of the highest in the United States, thus rivaling some others throughout the world, particularly in South America. The turning point for Silverton and the entire region came in the 1880s, with the arrival of the railroad.

Railroads were the fastest, cheapest, safest, and most comfortable way to get from here to there, and its arrival in a mining district usually translated into boom. For the Silverton mines, this meant the narrow-gauge Denver & Rio Grande (D&RG) Railroad. Built three feet wide, rather than to the standard four-feet, 8.5-inch gauge, it was cheaper to build, could round sharper curves, and climb steeper grades. The trade-off, however, meant smaller cars and less powerful engines.

The arrival of the D&RG in Silverton in 1882 saved the day for local mining. The cost of living declined, transportation drastically improved, and the quality of life changed for the better. The railroad also solved another problem; by shipping ore down to Durango, a town it built, the ore reached the region's best and most modern smelter. That, of course, meant that some of Silverton's struggling mills and smelters were forced out of business.

Now, instead of being weeks, or months, away from Denver and the outside world, travel had been reduced to days. Investors, mining engineers, miners, settlers, and a variety of merchandise and mining equipment could arrive with ease and comfort unknown previously. While winter weather and snowslides could slow and even stop the iron horse for a while, isolation would never handicap the region as it once had.

As all of this unfolded, it illustrated that the San Juans did not represent the typical frontier. Urbanization came with the early settlers. With Silverton serving as the core of it, mining took root in the heart of the San Juans. Around the town grew a group of small mining camps that lasted as long as nearby mines produced ore. Then the vast majority disappeared into legend.

Meanwhile, with transportation improved, smelting available, and skilled mining engineers and miners moving into the region, mining production reached heights never before attained. From a total of $13,586 in 1874, it jumped to $1,006,500 in 1886, and topped $2 million a decade later. There seemed to be "buckets galore of silver ore" wherever one prospected. The silvery San Juans were indeed just that, despite the fact that the price of silver dropped from $1.27 to 63¢ per ounce in that same period. Gold production would not top $1 million until 1898.

One fact that certainly kept the San Juans in the news was the continual opening of new districts from the 1870s into the 1890s. All of this occurred in a triangle, with its points being the three major mining towns of Silverton, Telluride, and Ouray. While gold started the excitement and silver kept it going, copper, lead, zinc, and even coal, near Durango, made this a mineral treasure box seldom seen throughout the mining West.

As was typical, scoundrels, fly-by-night operators, con men, and others of a similar ilk preyed on the gullible and greedy. Mining seemed to promise the easy opportunity to make money, whether it was at Silverton, Leadville, or Virginia City, Nevada. As one miner said, he had never worked so hard in his life to get rich without working. Another observation put it more bluntly: "Mining interests are greatly damaged by exaggerated reports of persons eager to sell properties first. Investors are so often misled by false statements and misrepresentations."

True, unfortunately, was also the fact that much of the money that was made left the county going to where the investors lived. While attention is usually focused on those who made millions, most of them were from outside San Juan County.

The other noticeable trend during these decades was consolidation of properties into larger operations. It proved just too costly for a small mine to operate when the expense of mining went up over the years, while silver's price went down. Thus, larger companies bought out the neighboring claims. Working on a larger scale, they hoped that profitable operations would continue. Unfortunately, however, the cost of mining rose the deeper one mined; meanwhile, the ore generally became lower grade.

Nor did the miners share equally during the days of prosperity. Wages stayed fairly steady as the cost of living rose. There soon arrived new power drills, electricity, blasting powder, and other improvements, which allowed fewer men to do the work. The crews became smaller and their production rose, but wages seldom budged. There lay the root of trouble that exploded after the turn of the 20th century. Then, as the century passed, it was harder to find skilled miners, as higher-paying occupations lured them away from districts throughout the West.

The era came to an end near the start of war breaking out in Europe in 1914. The easy-to-recover silver and gold deposits were gone. No new districts were opening, and the excitement waned. Mining, however, would continue in the Silverton area into the 21st century. And there are those who believe major deposits still remain hidden in the towering mountains around the town and that tomorrow may produce the big bonanza.

—Duane A. Smith

One

SILVERTON

Silverton. The little town's name itself suggests its rich mining history—"tons of silver"—not to mention gold and base metals. It began its life in 1874 and quickly became the major supply center to the mines that were being located throughout the area. To further assist in the distribution of mining equipment, clothing, food, and mail, a number of smaller satellite mining camps were built in the Las Animas River drainage and adjacent areas, including Howardsville, Eureka, Animas Forks, Mineral Point, Gladstone, Chattanooga, and Red Mountain. These camps were located as close to the major mines as possible and, in fact, depended on these mines for their very existence. In later years, as the mines were abandoned, so too were the mining camps—only Silverton remains today.

Transportation was the key to Silverton's longevity. In such a remote area, with high elevations and mountain passes to overcome, even construction and maintenance of wagon roads was very difficult, especially in the winter with extreme cold and mountain snows. And travel times were measured in weeks or months. But the arrival in Silverton in July 1882 of the Denver & Rio Grande Railroad connected it to the outside world, and now it took only days to get supplies into town and ore and bullion out. At one time, four railroad companies operated in and out of Silverton, thus ensuring faster, cheaper, and year-round shipping.

Silverton survived through mining booms and busts until August 1991, when the Sunnyside, the last major mine operating in the area, closed for the final time. Since then, tourism, not mining, has kept the town alive, principally the Durango & Silverton Narrow Gauge Railroad (D&SNGRR) tourist train, which operates on the tracks of the old Denver & Rio Grande Railroad.

For a good overview of Silverton's history, see Duane Smith's *Silverton, A Quick History*.

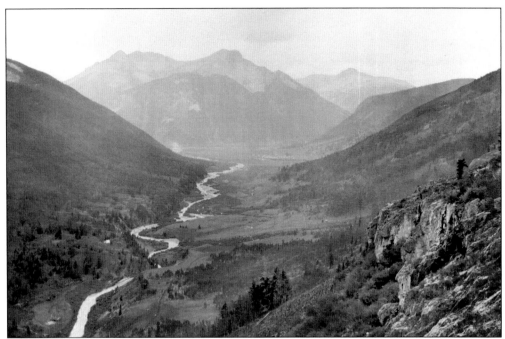

BAKER'S PARK, 1875. This William Henry Jackson photograph, looking southwest, shows the Animas River winding through Baker's Park with Silverton located in the distance. The park is named after Charles Baker, who in 1860 brought a group of prospectors to the San Juan Mountains and located small amounts of placer gold in the area. Sultan Mountain rises behind Silverton. (Photograph by William Henry Jackson; courtesy of the US Geological Survey.)

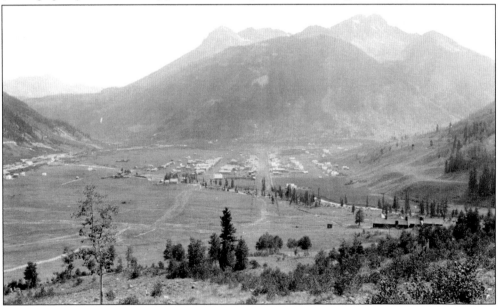

SILVERTON, 1870s. This view of Silverton is also looking southwest, directly along the path of Greene Street with Sultan and Grand Turk Mountains in the background. The Greene and Company Smelter can be seen in the foreground on the right. (Photograph by William Henry Jackson; courtesy of the Denver Public Library, X-1713.)

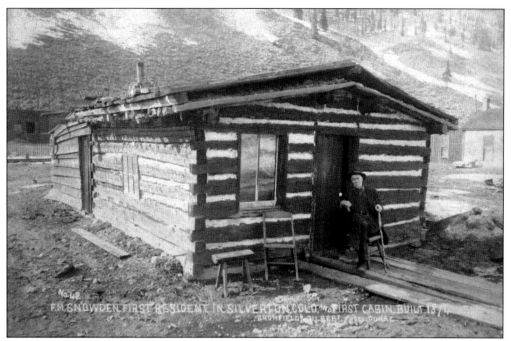

FRANCIS SNOWDEN CABIN, 1890S. Francis Marion Snowden was the first resident of Silverton and is seen here sitting in front of the one-room hewn-log cabin he built in 1874. The roof had two layers of wood with dirt between the layers. The Miner's Union Hospital now stands on this site. (Courtesy of the Denver Public Library, X-17497.)

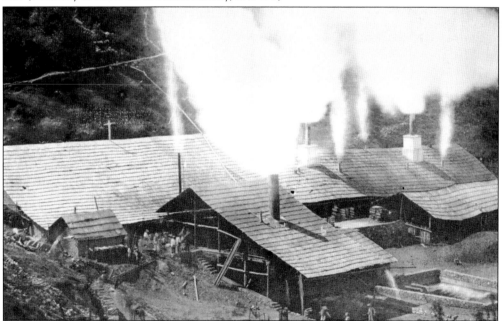

SILVERTON'S FIRST SMELTER. Greene and Company built Silverton's first smelter in 1874 or 1875 to reduce ores by heating them in a furnace. This image was taken in the late 1870s and shows the smelter in full operation belching fumes from all its smokestacks. (Courtesy of the Denver Public Library, X-61438.)

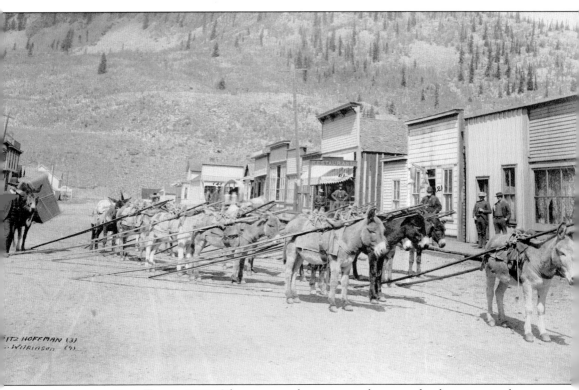

SILVERTON PACK TRAIN, 1892. Silverton was the main supply center for the mines in the area. This pack train of burros is ready to depart with a load of rail for the mines. Fritz Hoffman, left, is standing next to a mule carrying an ore car. This view shows most of the Thirteenth Street commercial district between Greene and Reese Streets. The building on the far left is the office of the *La Plata Miner* newspaper. Other businesses include the Walker House (white building with curved sign on the left at the end of the street), the St. Charles Restaurant, and a boot and shoe shop with a hanging boot as a sign. Dr. W.W. Wilkinson (labeled number four in the center of the image) is standing in front of Benjamin Taft's drugstore. Francis M. Snowden is on the right, under the restaurant awning. Snowden's cabin is located at the far end of the street on the right.

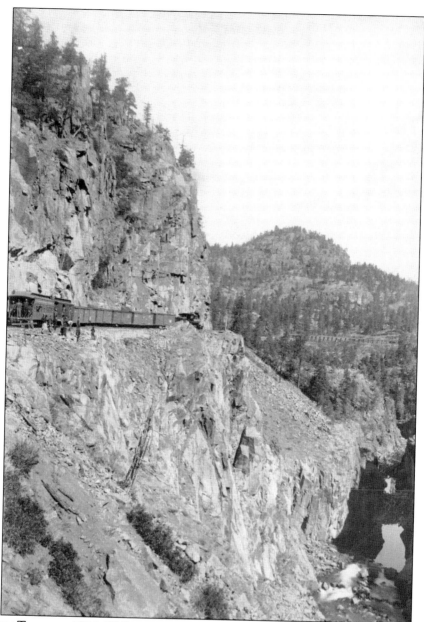

SILVERTON TRAIN, C. 1890. William Jackson Palmer's Denver & Rio Grande (D&RG) Railroad steamed into Silverton in July 1882. This insured that Silverton would remain the area's main supply town. The Silverton Branch, or high line, of the D&RG had to negotiate the rugged terrain of the Canyon of the Rio Las Animas (Animas Gorge) north of Rockwood and was rumored to cost $1,000 per foot to build. This view shows a narrow-gauge engine with freight cars, a work car, and a passenger coach stopped on a narrow rock ledge high above the Animas River. A number of men and women have departed the train for this photo opportunity. In the distance, a wooden railroad trestle can be seen. Today, thousands of tourists each year make this same trip on the Durango & Silverton Narrow Gauge Railroad. This historic train has been in continuous operation since its arrival in Silverton. (Photograph by W.J. Carpenter; courtesy of History Colorado, CHS.X9259.)

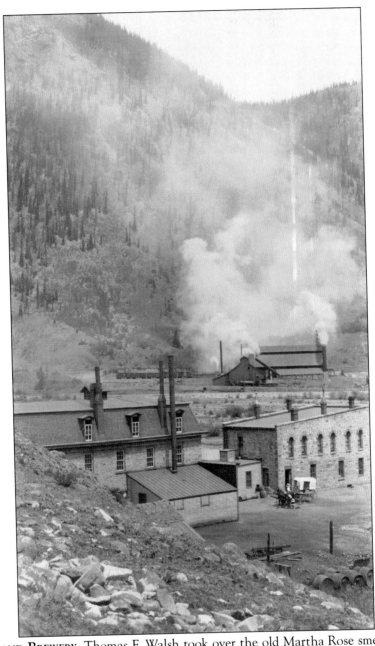

SMELTER AND BREWERY. Thomas F. Walsh took over the old Martha Rose smelter in 1894, installed new equipment, and started processing ores from the Red Mountain Mining District. This scene, looking north, shows Walsh's smelter on the bank of Mineral Creek emitting clouds of smoke. A number of freight cars of the Silverton Railroad are located on the spur next to the smelter buildings. While looking for low-grade ore for his smelter, Walsh discovered the Camp Bird Mine near Ouray and later became a millionaire. In the foreground are the brick buildings of the Fischer Brewery and ice plant. A horse-drawn wagon with lettering reading "Silverton Dairy" is parked near the door. A girl is emerging from the building wearing a wide-brimmed hat. Wooden barrels are piled near a smaller outbuilding in the foreground (Courtesy of the Denver Public Library, X-1739.)

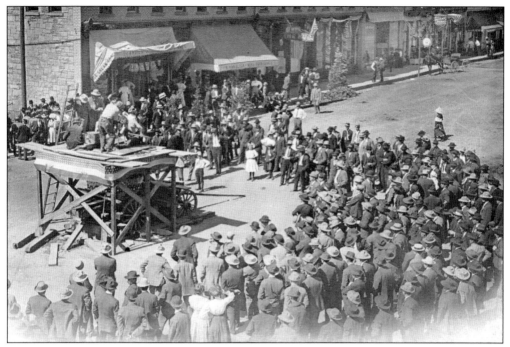

DRILLING CONTEST, 1909. Holidays like the Fourth of July were a time for the miners to come to town and celebrate, and drilling contests were very popular. Here, a double-jack rock-drilling competition is taking place in front of the Grand Hotel on Greene Street. The rock being drilled into is mounted on a wagon, and the competition platform is built over it. A confectionery and a men's furnishings store are across the street from the contest.

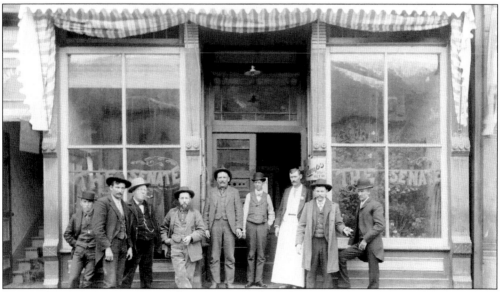

SENATE SALOON, 1898. After working long periods in the mines, miners came to town to let off a little steam. Bars like the Senate Saloon on Greene Street were often their first stop. Saloons were also the meeting place for Silverton men to relax after work. The man with the white apron is bartender Hi Washburn.

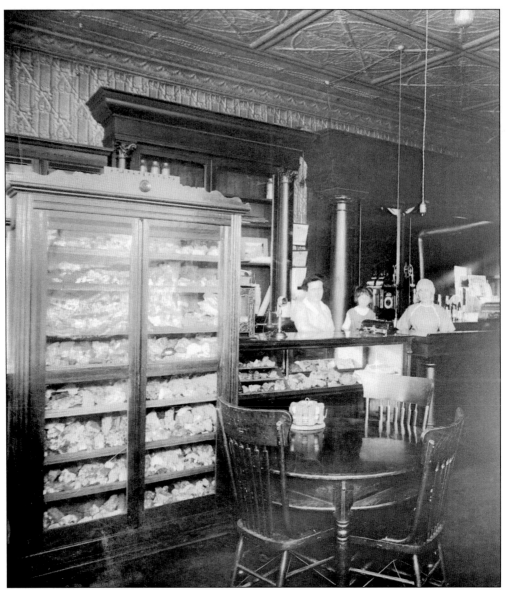

PIEMONTE SALOON, C. 1918. John B. and Caterina Perino Giono ran a saloon and boardinghouse on the southwest corner of Thirteenth and Blair Streets known as the Piemonte. It was presumably named after the Piedmont region of Northern Italy that was home for many Silverton immigrants. John was active in mining, having leases on a number of properties, including Pride of the West, Iowa-Tiger, and Unity. Many saloons and banks had cases displaying ore samples from the surrounding mines such as the one on the left. This interior view of the saloon also shows an intricate match machine just to the right of the case, a telephone on the bar, poker chips on the table, and a beautiful back bar and furnishings. Caterina Perino Giono, the proprietor, is standing on the left, and Lydia Giono (McCarrier) is on the right. The girl in the center is not identified.

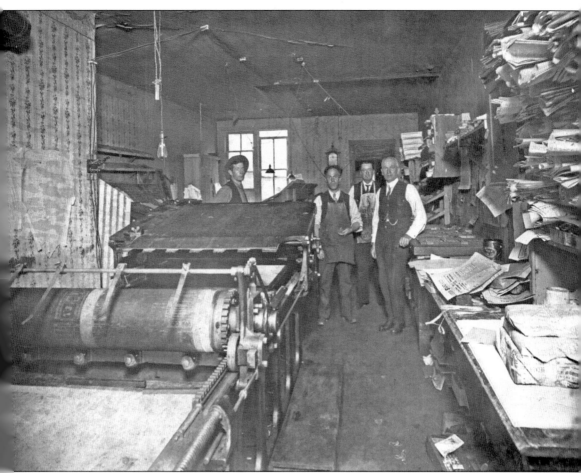

SILVERTON STANDARD, c. **1910.** Newspapers were essential for promoting the mines in the area. The *La Plata Miner* began publishing in 1875, and the *Silverton Standard* began in 1889. The two papers merged in 1920 as the *Silverton Standard & the Miner,* and it is still published today, making it the oldest continuously operated newspaper on the Western Slope of Colorado. This view of the interior of the *Silverton Standard's* print shop at 1117 Greene Street shows the flatbed cylinder press, type stands, and newspaper files. The four men in the image are, from left to right, John Joyce (owner and publisher), Ed Hillman (printer and future owner), Dick Brown (printer and future postmaster), and Lewis Hass (clerk at Bordeleau Hardware). In 2009, the San Juan County Historical Society became the owner of the newspaper, insuring its continued publication.

SULTAN MOUNTAIN, C. 1900. The above photograph is of the upper workings of the Champion Mine, located on Sultan Mountain southwest of Silverton. The building on the right was used to conduct preliminary ore sorting by use of a hand-jig. A jig is an apparatus used to concentrate ore by a reciprocating motion on a screen submerged in water. The photograph below of a small miner's cabin or boardinghouse, possibly at the Champion Mine, is typical of many small operations throughout the San Juan Mountains, where the living conditions could be quite primitive. In this case, the woman shown could have been the cook for this operation.

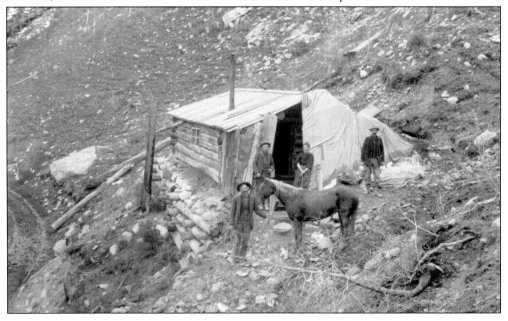

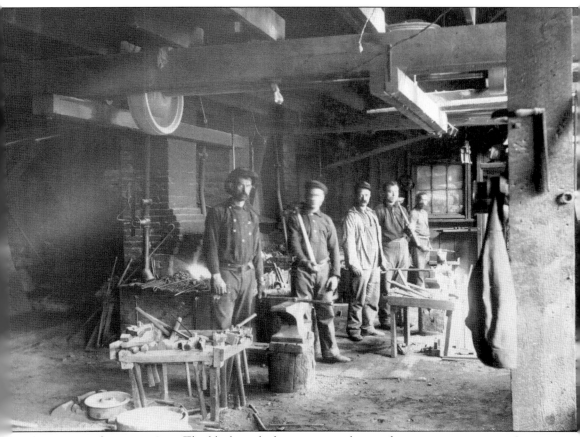

Blacksmith Shop, c. 1900. The blacksmith shop was a vital part of any mining operation. In addition to the never-ending job of sharpening drill steels every day, all sorts of items needed to be repaired. These unidentified men are seen working in the blacksmith shop that is thought to be at the Hercules Mine on Sultan Mountain. Anvil, forge, and tools are clearly visible.

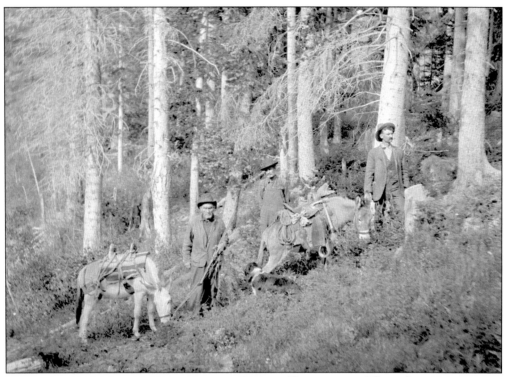

PROSPECTORS. These three prospectors, from left to right, Orville Bradford, Charles H. Stockman, and George D. Brown, were working their properties at Ice Lake in August 1913. Here, they are pictured in the woods near the mill with their burros and dog.

BEN HARWOOD. Often, miners would have studio portraits of themselves taken to send back home to family, like this one of Ben Harwood holding a hand steel and single jack on a rustic platform setup in front of the Brumfield Studio backdrop. Other mining tools, including a pick, are nearby. Harwood was one of the pioneers of San Juan County.

Two

RED MOUNTAIN

The Red Mountain Mining District is located between Ouray and Silverton, near Red Mountain Pass. The district is seen by thousands of tourists every summer as they travel the Million Dollar Highway. The district had a slow start compared to other districts in the San Juans, with only a few claims being staked by the end of the 1870s. Heavy snows and unusual geology hindered prospectors' progress. Activity boomed in the 1880s after it was discovered that rich silver-lead and silver-copper ore were found in narrow chimney-like deposits as opposed to veins. In the 1880s, people had pinned their hopes on Red Mountain Mining District becoming the second Leadville. Although the ore was incredibly rich, the deposits were limited, and the district never competed with Leadville. Most of the Red Mountain mines closed in the 1890s due to the Silver Crash of 1893 and the increasingly corrosive water in the mines.

Red Mountain Town, Ironton, and Congress sprang up to provide local services to the miners of the area. The Guston, Yankee Girl, Genessee-Vanderbilt, Robinson, and National Belle Mines were the major producers in the district. The towns of Silverton and Ouray openly fought to position themselves as the dominant supply center for the Red Mountain Mining District, with Silverton eventually winning out when Otto Mears brought his Silverton Railroad into the area. Mears started construction of the Silverton Railroad from Silverton in the summer of 1887, arriving in Red Mountain Town in September 1888 and Ironton the following year. The railroad gave the mines in the district cheaper access to the smelters in Silverton and Durango, thus allowing owners to economically process lower-grade ores.

A detailed history of the Red Mountain Mining District can be found in P. David Smith's *Mountains of Silver*.

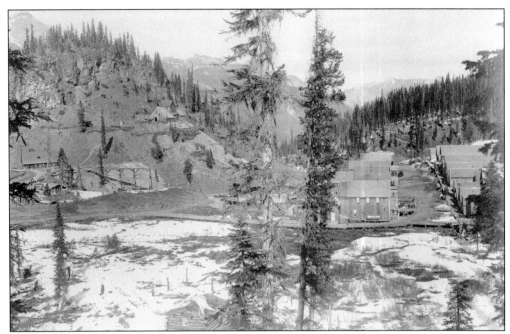

RED MOUNTAIN TOWN, 1888. In the 1880s, Red Mountain Town was an important mining camp in the Red Mountain Mining District. This view of the town is looking northwesterly up the main street. On this street there was a hotel, clothing and dry goods store, livery stable, and meat market. The main shaft house for the National Belle Mine is located on the side of the hill on the left.

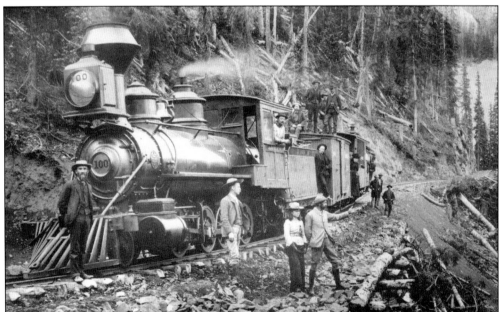

SILVERTON RAILROAD NEAR RED MOUNTAIN. Otto Mears stands in front of Engine No. 100. This was the first passenger train to arrive in Red Mountain Town, on September 17, 1888. The man to the right of Mears is C.W. Gibbs, who was chief engineer in charge of building the Silverton Railroad. (Photograph by Charles Goodman; courtesy of the Denver Public Library, Z-1425.)

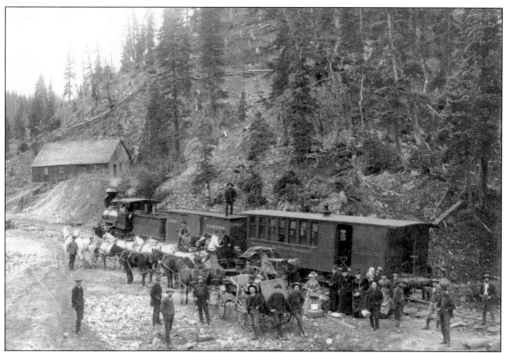

RED MOUNTAIN PASSENGERS, 1888. The first Silverton Railroad passenger train arrived in Red Mountain Town on September 17, 1888. Here, passengers are being transferred to waiting wagons to continue their trip. Otto Mears is standing next to the rear steps of the combination passenger-baggage car. (Photograph by Charles Goodman; courtesy of the Denver Public Library, Z-5488.)

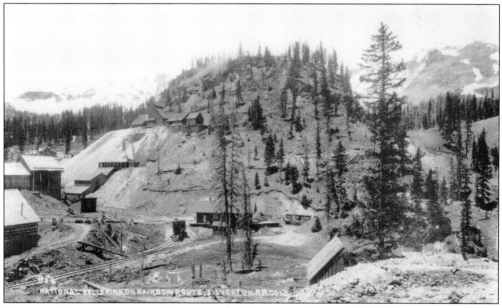

NATIONAL BELLE MINE, 1890. The National Belle Mine, which tapped a large siliceous knob (seen in this photograph) that turned out to be an incredibly rich chimney deposit, operated until 1897 and produced silver worth between $1 and $2 million. Engine No. 100 stands on the wye next to the railroad depot. (Photograph by Charles Goodman; courtesy of Duane A. Smith.)

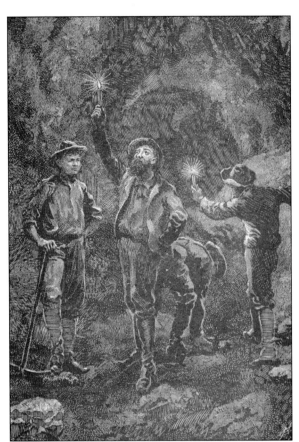

NATIONAL BELLE CAVERN, 1883.
In July 1883, while determining
the extent of the ore body, miners
in the National Belle Mine broke
into a large cavern. The walls of
the cavern were covered with high-
grade silver ore. Apparently no
photographs were taken in the cave,
but this illustration depicts what
this cavern might have looked liked.
(Courtesy of Karen and Mark Vendl.)

YANKEE GIRL CREW, 1889. The
Yankee Girl Mine was discovered by
John Robinson on August 14, 1882,
during a hunting trip. While resting,
he noticed a rock that contained
silver-bearing galena. By 1883, a
large crew of miners was working
at the Yankee Girl. The tracks in
the foreground lead to the first-level
mine entrance (adit). (Courtesy of
the Denver Public Library, X-62121.)

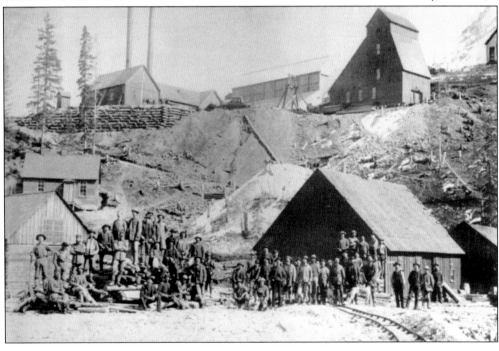

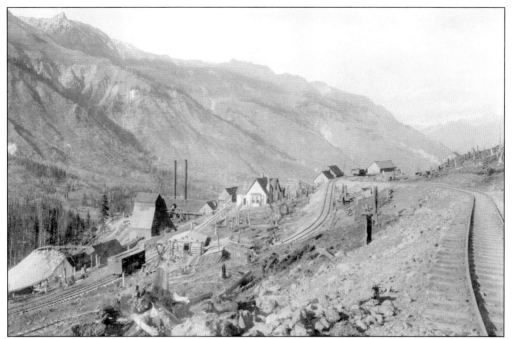

YANKEE GIRL TRACKS, C. 1890. The Silverton Railroad served most of the major mines in the Red Mountain Mining District. This view of the Yankee Girl Mine looking north shows the tracks that served the mine. A boxcar sits on the track near the shaft house. (Photograph by William Henry Jackson; courtesy of the Denver Public Library, WHJ-1359.)

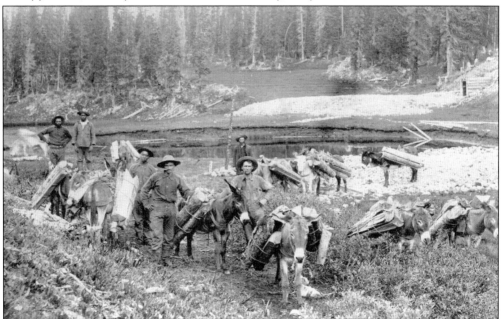

PACK TRAIN, NOVEMBER 1888. This crew of six men, apparently employed by the Yankee Girl Mine, is transporting split wood by burros. The three men on the left are African Americans. This is one of the few photographs of African Americans as part of the workforce in the mining industry in this area at that time. A small timbered portal is visible at extreme right.

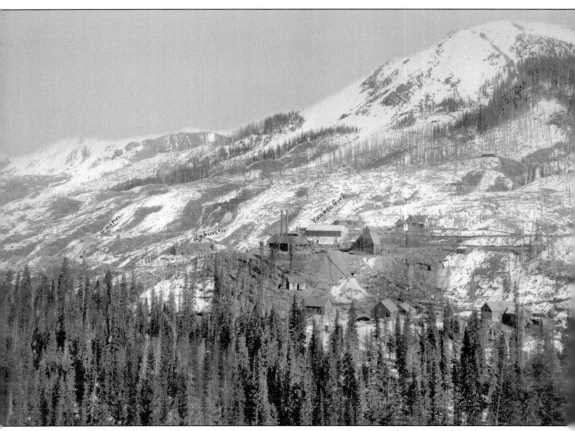

RED MOUNTAIN MINING DISTRICT. This panorama shows the central portion of the Red Mountain Mining District about 1885, at the height of mining in the area. Taken in a southeasterly direction from near the foot of Commodore Gulch, the summit of Red Mountain No. 2 is at right, and the flank of Red Mountain No. 1 is visible on the left. Much of the ground is covered with snow, and the mountainsides bear evidence of relatively recent timber cutting. This view shows the relative positions of the mines in this area. From left to right are the Guston, Robinson, and Yankee Girl Mines, with structures of the Yankee Girl the most prominent to the right of center.

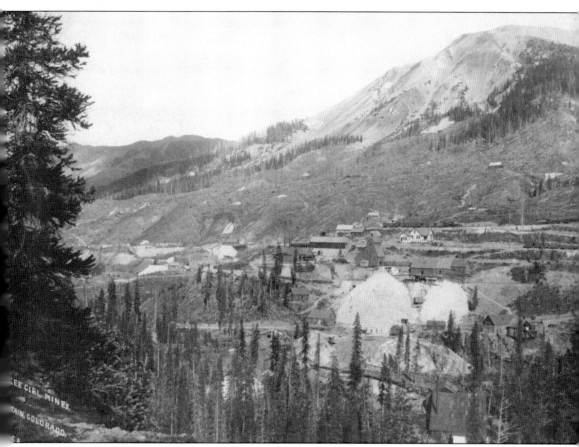

YANKEE GIRL MINE, 1891. This scene is looking east at the Yankee Girl Mine, which was in full operation when this overview was taken. The shaft house is located in the center of the photograph, with mine tailings below it. The structure with the two smokestacks contained the boilers, and the long building above the shaft house was the coal shed. Two trains can be seen on the Silverton Railroad tracks above and to the right of the Yankee Girl. The train on the left is the Silverton's Shay No. 269 with five boxcars. To the right coming from the other direction is Silverton Railroad's No. 100 with a passenger coach. Many of the trees on the mountainside above the mine have been cut down for lumber. (Photograph by S.G. White; courtesy of History Colorado, CHS.X4966.)

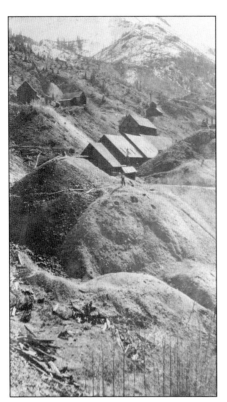

GUSTON MINE. The Guston Mine was another of the major mines in the Red Mountain Mining District. It was discovered in 1881 by August Dietlat, Andrew Meldrum, John Robinson, and Albert Lang. Originally mined for lead to be used as flux in the smelters, it went on to produce an estimated $6 million in silver before it closed in 1897.

RED MOUNTAIN NO. 3, 1907. The large, light-colored dump in the center of this image is that of the Genessee-Vanderbilt Mine. The mine in front of this dump is the Yankee Girl. Construction of the Joker Tunnel began in 1904 with the purpose of draining the workings of these mines. (From *The Golden San Juan,* published by the *Silverton Miner,* 1907.)

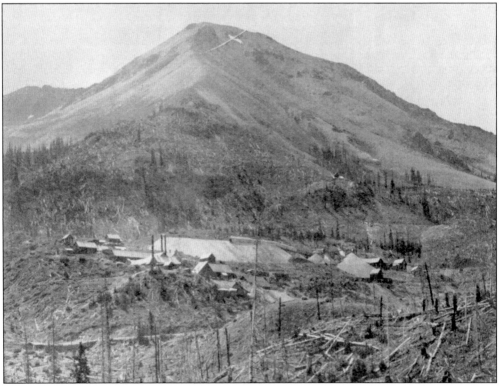

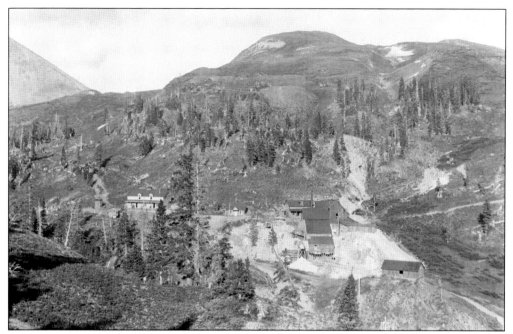

CARBON LAKE MINE, 1908. The Carbon Lake Mine was discovered in the summer of 1881 and was located near the small town of Congress. This view of the Carbon Lake Mine shows the mill with the slanted roof on the right. The white structure on the left is probably the miners' boardinghouse. Supplies and ore had to be transported to and from the mine by wagon.

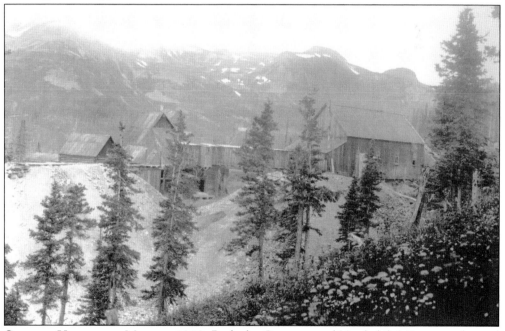

GENESSEE-VANDERBILT MINE, c. 1908. Both the Genessee and Vanderbilt Mines were located in 1882, and they merged in 1889. Production from the mine eventually totaled $1 million worth of gold, silver, lead, and copper. This view shows the mine portal and shop structures along with the waste dump.

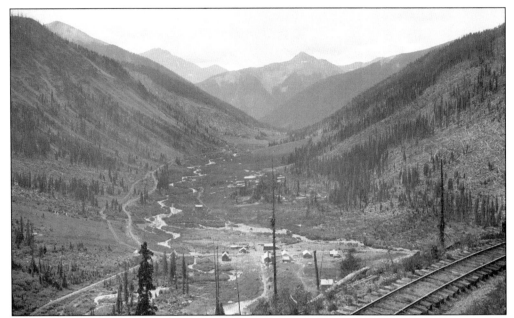

CHATTANOOGA, C. 1900. The town of Chattanooga was no more than a small collection of log and wood-frame buildings. The Silverton Railroad made a large loop here before climbing to Red Mountain Pass. In the distance in the center of the photograph is Bear Mountain, named for the patch of forest that looks like a bear and a honey pot. (Photograph by William Henry Jackson; courtesy of the Library of Congress.)

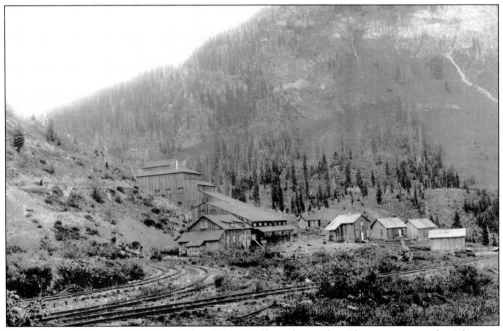

SILVER LEDGE MILL, C. 1908. The Silver Ledge Mill was located at Chattanooga on the Silverton Railroad, and in 1904, a zinc plant was installed at this mill. It burned in 1919, and the mine closed down. Two tram towers are visible above the mill, leading to the mine, up the North Fork of Mineral Creek to the left.

Three

LAS ANIMAS MINING DISTRICT

The Las Animas Mining District was organized in June 1871, making it one of the first in the area, and it is located southeast of the Animas River and west of Cunningham Gulch. Some of the earliest silver mines in the San Juan Mountains were located in this district in the early 1870s, including the Little Giant, North Star, King Solomon, Sultan, Aspen, Whale, Iowa, and Silver Lake.

The Silver Lake Mine was located in 1873, but it was not really developed until the 1890s, when new milling practices made possible the processing of large tonnages of low-grade gold and silver ore. Edward Stoiber first built a mill at Silver Lake, but he later built a larger mill on the Animas River that was connected to the mine by an aerial tram. Under Stoiber's expert guidance, the Silver Lake Mine became one of the largest mines in the West, and by 1899, it had 35,000 feet of underground workings.

During the Great Depression, when most mines in Colorado closed, Charles Chase was able to keep mining alive in Silverton by employing 150 men at the Shenandoah-Dives Mine. He managed this by being frugal and innovative, even convincing his men to take a 25-percent pay cut to keep the mine open. In 1929, he built the Shenandoah-Dives (also referred to as the Mayflower) Mill, which is now owned by the San Juan County Historical Society.

For a detailed look into the history of the Las Animas Mining District, read Eric Twitty's book *Basins of Silver*.

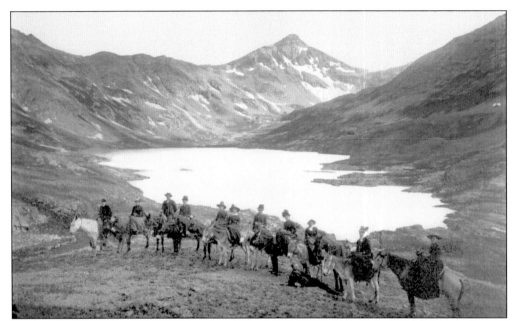

ARRASTRA LAKE, 1887. Arrastra Lake (later known as Silver Lake) is located high above Silverton at the head of Arrastra Gulch. In 1887, the Silverton Walking Club took a horseback trip to Arrastra Lake. The group consisted of 12 men and women; the women rode sidesaddle, and they stopped to have this photograph taken. This view, taken before mining took hold, is from the northeast corner of the lake.

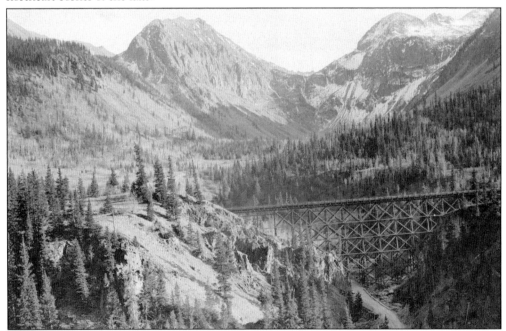

ARRASTRA GULCH, C. 1900. Arrastra Gulch is the location of some of the earliest mining efforts, such as the Little Giant, the first hardrock mine in the San Juans. This photograph is looking southeasterly up Arrastra Gulch from across the Animas River. The Silver Lake flume and trestle, seen here crossing Arrastra Gulch, provided water to Edward Stoiber's hydropower plant.

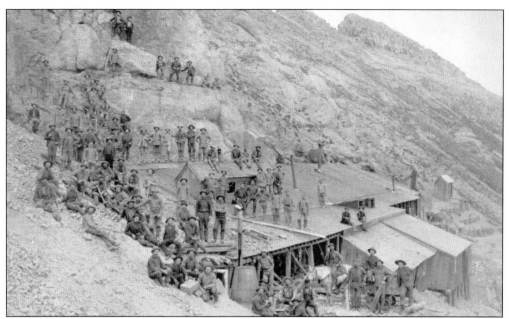

NORTH STAR MINE, NO. 4 LEVEL, DIVES BASIN, 1888. One of the earlier silver mines in the Las Animas Mining District was the North Star Mine, located at 12,965 feet on the side of Little Giant Peak. Here, a large group of men, some playing cards, are assembled at the building covering the entrance to the mine. Waste rock was dumped from the wooden ore car (seen to the right of the man on the horse) down the side of the mountain.

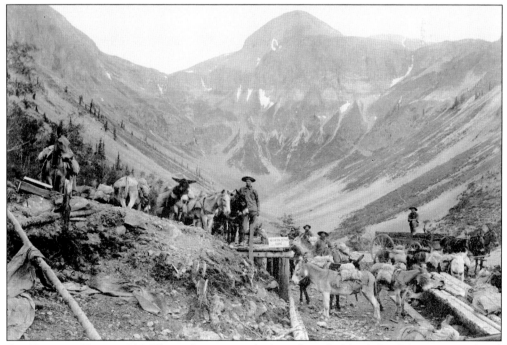

ORE TRANSFER POINT, 1888. This is the point at which ore from the North Star Mine was transferred from pack animals to wagons and then taken down Arrastra Gulch to Silverton. Round Mountain is located in the center background. The sign on the platform says "North Star Ore."

EDWARD AND LENA STOIBER. Edward G. Stoiber was a mining engineer from Germany who attended the School of Mines in Freiberg. Along with his brother Gustavus, Edward obtained 200 claims at the head of Arrastra Gulch, establishing the Silver Lake Mine in the mid-1880s. In 1887, the two bothers had a disagreement, and they dissolved their partnership. Edward retained the Silver Lake Mine, and along with his wife, Lena, he turned it into one of the most profitable mines in the San Juans. Edward ran the engineering side of the mine, and Lena took care of bossing all the miners. Lena was not above going down to Silverton bars and dragging miners back to work. It was said she paid her miners twice a year, on Christmas and the Fourth of July. Because of her tough demeanor, she was known as "Captain Jack." A mine "captain" was parlance for shift boss at the time.

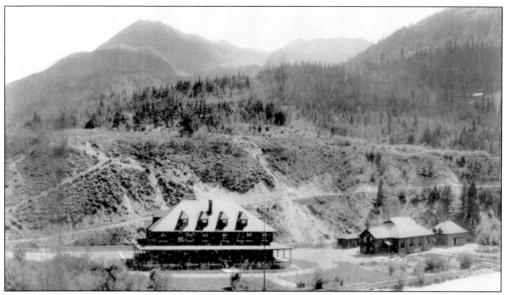

STOIBER MANSION, C. 1900. With the great profits from the Silver Lake Mine, the Stoibers built a mansion near Silverton that was completed in 1897. They named their combination home and office Waldheim, or forest home. The mansion had a long porch and dormer windows, a ballroom, a theater, and a conservatory. On the right is the hydropower plant that provided electricity for the mine and mill at lake level, as well as the mansion. (Photograph by H.F. Peirson.)

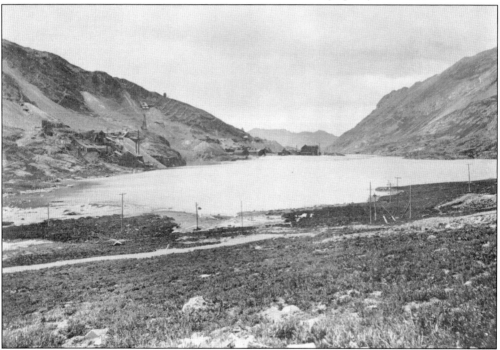

MINES AT SILVER LAKE, 1906. This view is from the south end of Silver Lake looking north. The buildings of the Iowa Mine, developed by Gustavus Stoiber, can be seen on the left. The buildings of the Silver Lake Mine are visible in the distance at the north end of lake. In 1901, Edward Stoiber sold the Silver Lake Mine to the American Smelting and Refining Company.

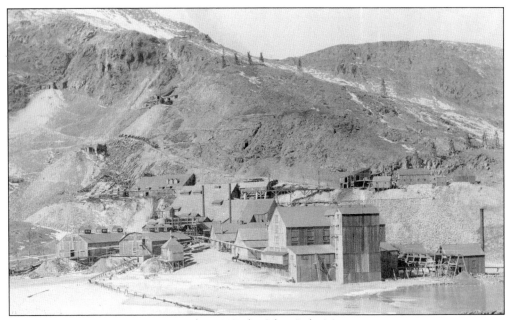

SILVER LAKE MINE, 1897. In September 1897, the Silver Lake Mine operation was quite extensive for such an isolated location. The large building in the center is the mill, and the structure above and to the left of it covered the main entrance to the mine. On the skyline can be seen some of the aerial tram towers of the Iowa Mine. The building to the lower right is the five-story boardinghouse.

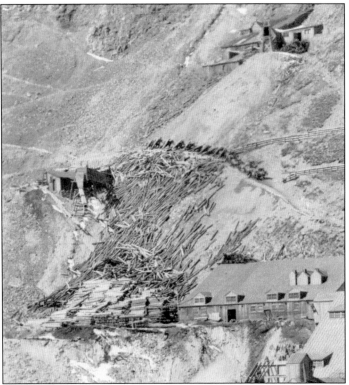

MINE TIMBER, 1897. This image is a blowup of a section of the previous Silver Lake Mine photograph of the area just above the mine entrance. A string of pack animals carrying timber is lined up on the trail above. Timber is being unloaded here and dropped down the side of the mountain to the level of the mine entrance. Large amounts of timber were needed in the mines to support underground workings.

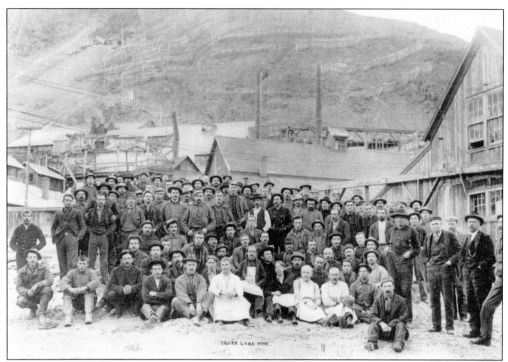

SILVER LAKE MINE CREW, MID-1890S. A large group of miners pose in front of the mine boardinghouse at the Silver Lake Mine. Prominent in this image is the cooking staff sitting up front. In 1900, there were 300 men living and working at the Silver Lake Mine, many of them immigrants from Austria, Italy, and Finland. (Courtesy of the Denver Public Library, X-60864.)

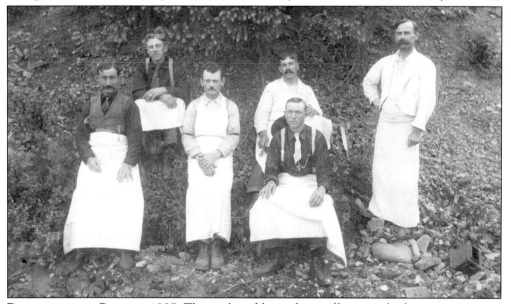

BOARDINGHOUSE CREW, C. 1897. The cook and his or her staff were truly the most important people at the mine. If the men were not fed plenty of good food, they would just tramp on to the next mine. This is the cooking staff at the Silver Lake Mill boardinghouse. Russell Niclos is second from the left, and Frank Harwood is second from the right in the dark shirt and tie.

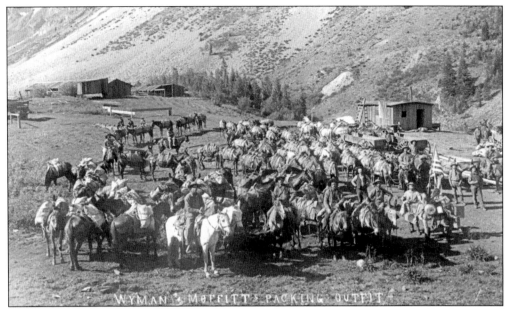

TRAIL CAMP. Packing outfits were essential to the operation of most mines in the San Juans, and no outfit was larger that the one owned by Louis Wyman. Starting from only 15 burros, by 1895 he built the business to include 140 pack mules, 65 burros, 5 six-horse teams, and 3 four-mule teams. Wyman's outfit hauled most of the equipment and material for the Silver Lake Mine. This photograph was taken in Arrastra Gulch.

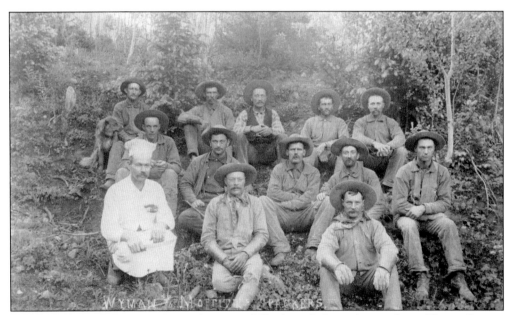

PACKING OUTFIT, C. 1905–1910. Packing was difficult work. Long days in the saddle in all types of weather on trails that barely existed took its toll. These packers are dressed in their riding clothes, ready to hit the trail. Louis George Wyman is the man in the center of the third row wearing a plaid shirt. (Photograph by Miller and Chase.)

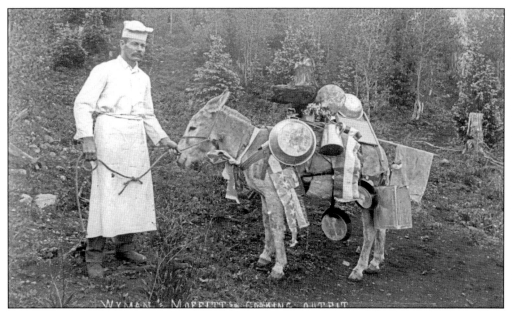

COOKING OUTFIT. As in the mine boardinghouse, the cook was a very important member of the outfit. Packers developed a strong appetite after long hours on the trail. Here is the cook for the Wyman outfit with a burro loaded with a variety of pots and pans. The burro seems to be decorated with bunting, possibly for the Fourth of July celebration.

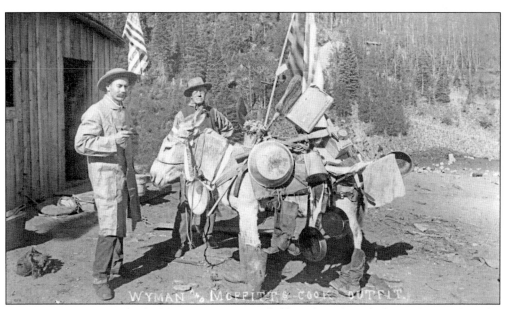

COSTUMED BURRO. It looks like Louis Wyman (left) and unidentified man have taken the celebration one step further. They have taken the "cook outfit" burro and costumed it in different fashion, including a ribbon around the burro's head, flowers in a can on the burro, and boots on all the burro's feet. Wyman was known for always treating his animals well.

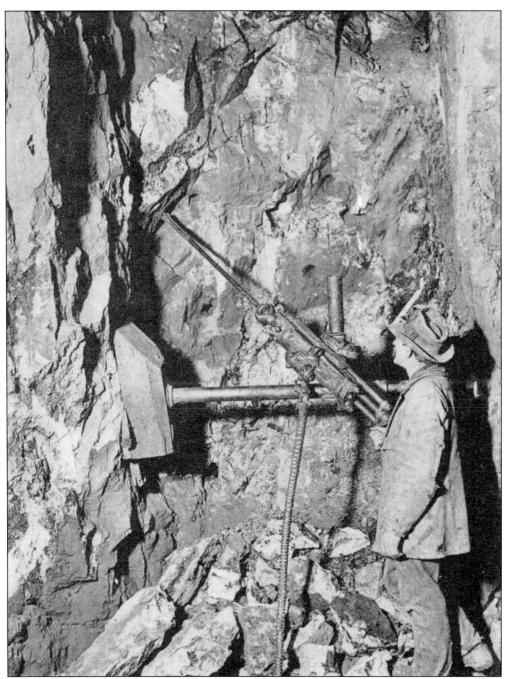

DRILLING UNDERGROUND. Here, a miner is drilling blasting holes on a vein 3,000 feet underground in the Silver Lake Mine. This air-hammer drill is mounted on a bar spanning the width of the vein. These drills used compressed air to drive a drill steel into the rock, creating lots of dust and rock fragments. These drills were referred to as "widow-makers" because the miners would inhale the sharp dust particles, which damaged their lungs. Many a miner died young from developing what was called "miner's consumption" or silicosis. George Leyner would later develop a water-flushed drill that dramatically cut down on the dust. (Courtesy of Tom Rosemeyer.)

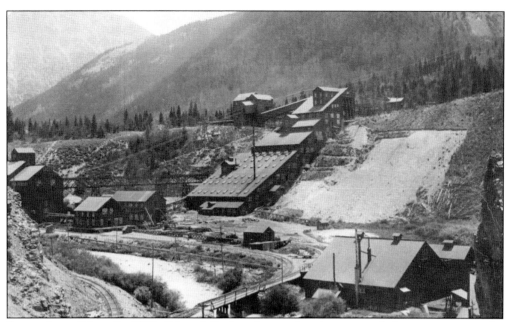

SILVER LAKE MILL. In 1900, Edward Stoiber designed and supervised the construction of a 200-ton-per-day mill located on the Animas River. This mill was one of the most advanced in the San Juans. It was connected to the mine at Silver Lake by an aerial tramway, and the Silverton Northern Railroad provided service to the mill. This photograph was taken in 1901 or 1902. (Photograph by B.A. Woodward and Company.)

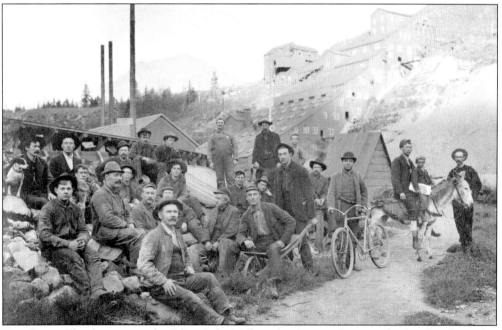

DAY CREW. The day crew at the Silver Lake Mill on the Animas River took a break to have this photograph taken sometime between 1900 and 1906. Various modes of transportation are shown, including a bicycle, wheelbarrow, and burro. The young boy on the burro looks like he might be delivering newspapers.

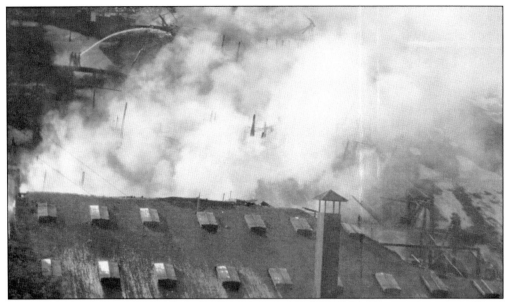

SILVER LAKE MILL FIRE, 1906. Early Friday morning, April 20, 1906, a fire was intentionally set in the Silver Lake Mill for no known reason. The night watchman discovered the blaze at 4:00 p.m.; the fire apparently started in the mill offices. Several men in the mill at the time responded to the fire but found that the fire hose nozzles were missing, which were later found near the river. Unable to effectively fight the fire, the men could not save the machinery and building; both were a total loss. These two images were taken from the storehouse and loading facility on the railroad siding and show several men hosing down the smoldering ruins.

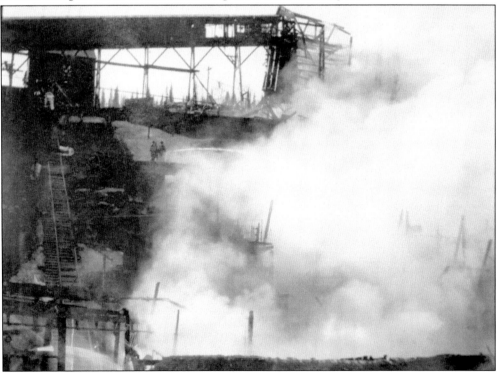

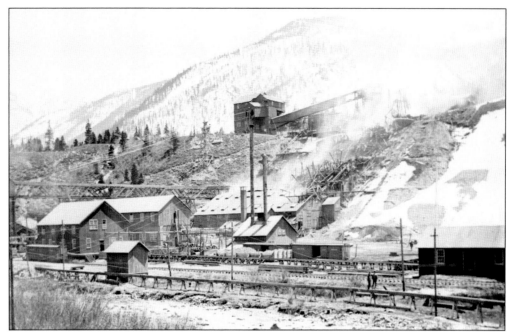

AFTER THE FIRE, 1906. This photograph was probably taken the day after the Silver Lake Mill fire on April 21, 1906, from the opposite side the Animas River. The main part of the mill was completely destroyed, causing $250,000 in damage. The shops, tram terminal, and upper conveyor were undamaged. In this photograph, the ruins are still smoldering.

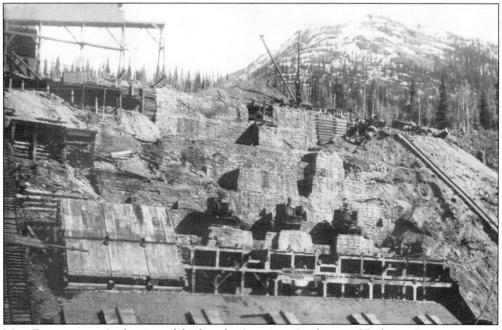

MILL FOUNDATION. At the time of the fire, the American Smelting and Refining Company owned the Silver Lake Mill. On May 8, 1906, the company announced that work on rebuilding the mill would begin at once. This image was taken June 5, 1906, after work had started on preparing the foundation for the new mill. (Courtesy of John Taylor.)

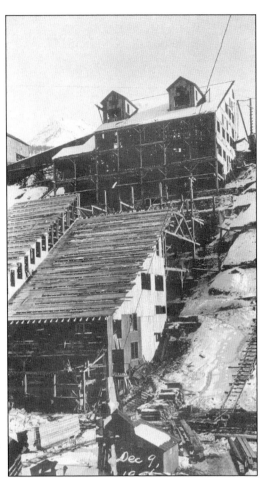

MILL UNDER CONSTRUCTION. Construction of the new mill began on September 15, 1906. This photograph was taken on December 9, 1906, and shows the progress that has been made. The framing can be seen for the upper portion of the mill, and new boards are being added to the lower portion. (Courtesy of John Taylor.)

NEW MILL BEING BUILT. This photograph taken on December 10, 1906, gives an overview of the Silver Lake Mill complex, showing the upper third and lower third of the mill under construction. Work on the mill continued throughout the winter. (Courtesy of John Taylor.)

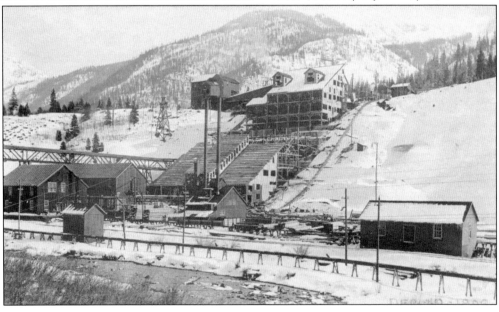

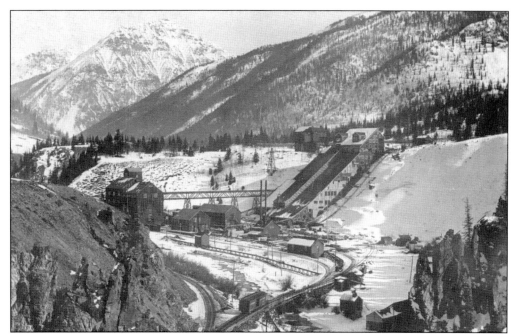

MILL NEAR COMPLETION. It was expected that the Silver Lake Mill would be completed by April 1, 1907. Work on the southwest side of the building was in progress, with most of the windows still needing to be installed and painting needing to be finished. Compare this photograph of the new mill with that of the old mill on page 41, taken from the same location.

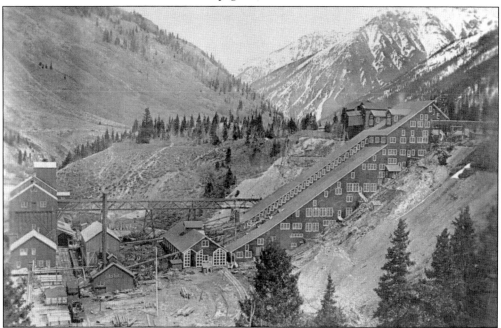

REBUILT MILL, C. MAY 1907. The new Silver Lake Mill went into operation on May 1, 1907, having cost an estimated $200,000. The mill was actually two separate mills in one building—part processing 300 tons per day of ore from the Silver Lake Mine and the other part 15 tons per day from the Aspen Mine. The warehouse yard and railroad spurs can be seen in this view.

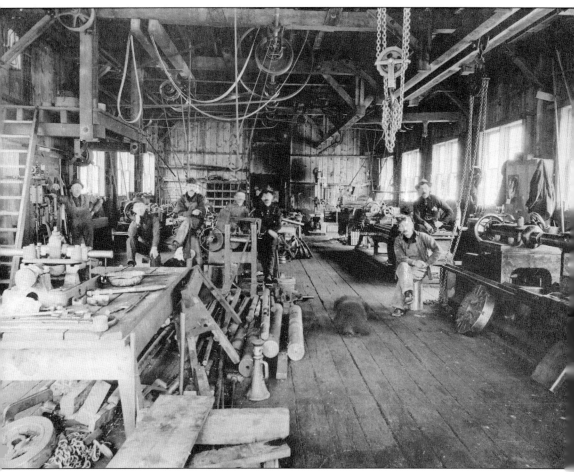

SILVER LAKE MACHINE SHOP. The machine shop was essential for the operation of any large mine. Due to the isolation of many of the mines, machinists needed to repair equipment or make parts from scratch because the mine could not afford to wait for parts to be delivered from Denver or Chicago. This is the machine shop at the Silver Lake Mine. Two large lathes are on the right, and a drill press is in the back. Much of the machinery is powered by an overhead belt system. Pulleys from the ceiling were used to lift heavy pieces of equipment or material. Seven men are seen facing the camera; they seem to have been busy reducing the local bear population, as there is the body of a dead bear on the floor.

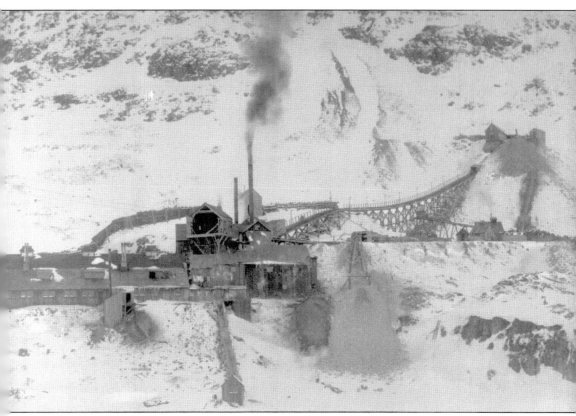

IOWA MINE, 1898. When Edward and Gustav Stoiber broke their partnership and split their properties, Gustav took the Iowa Mine, located on the same side of Silver Lake as the Silver Lake Mine. This image shows the structures at the Iowa Mine, with its surface trestle leading to the tram station at the mine entrance.

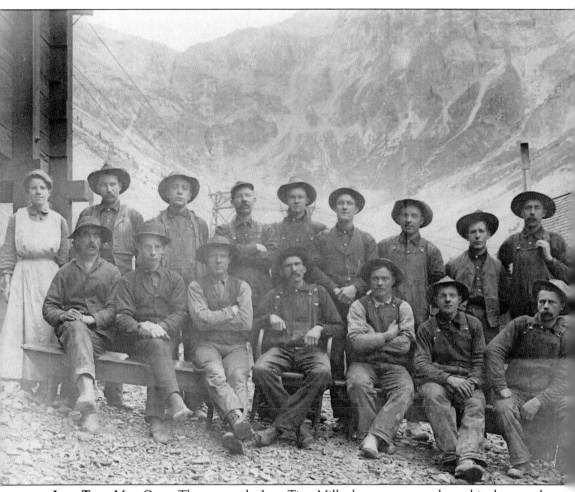

IOWA-TIGER MILL CREW. The crew at the Iowa-Tiger Mill takes a moment to have this photograph taken sometime between 1908 and 1913. Edvard Langlo is seated third from the right. The woman at the left was probably the cook for the boardinghouse. Women represented less than one percent of the workforce at mines in the San Juans; they added a feminine touch to an otherwise male world.

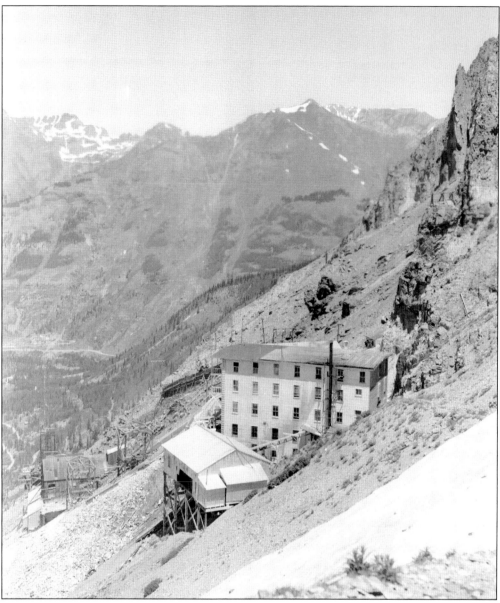

Shenandoah-Dives Mine. The Shenandoah-Dives Mining Company was a consolidation of a number of mines in Arrastra Gulch, including the Mayflower. The five-story boardinghouse for the Shenandoah-Dives Mining Company was located near the portal of the Mayflower Mine high above Arrastra Gulch. Built in the summer 1929, it provided housing for the miners right at the mine. The single men working in the mine were required to stay in the boardinghouse, which provided for all the men's needs and included a dining room, bakery, kitchen, recreation room, commissary, and first aid room. The upper two floors with the porches were the sleeping quarters, and the kitchen staff roomed in the basement, with the dining hall located on the first floor. The building immediately to the left of the boardinghouse was the stub tram house that was used to bring up supplies. Below that is the main tram house that was located at the mine entrance. The tramline leads straight down the mountain to the mill located in the valley. (Courtesy of Benjy Kuehling.)

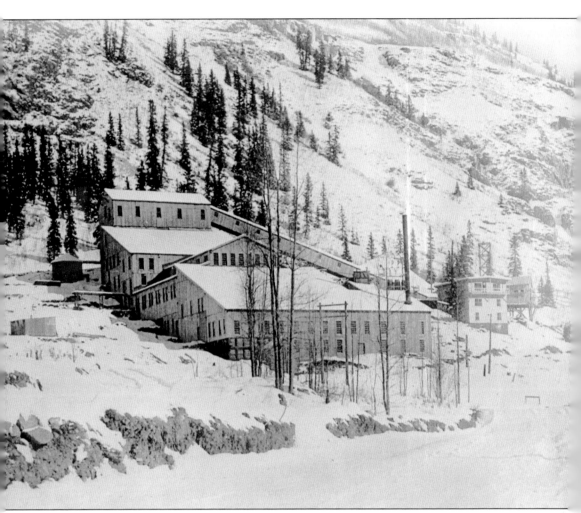

SHENANDOAH-DIVES MILL. In 1929, Charles Chase, the mine manager for the Shenandoah-Dives Mining Company, began construction of the flotation mill located near the Animas River at the mouth of Arrastra Gulch. Also referred to as the Mayflower Mill, it began operations early the following year at a cost of $375,000. Standard Metals Corporation rehabilitated the mill in 1960 to process ore from the Sunnyside Mine that was accessed through the American Tunnel in Gladstone. In 1991, the Sunnyside Mine closed, thus ending a 61-year milling career, the longest in the San Juan Mountains. The mill is currently owned by the San Juan County Historical Society after being donated by Sunnyside Gold Corporation in 1996. The mill received National Historic Landmark status in 2000, and tours can be taken from June through Labor Day.

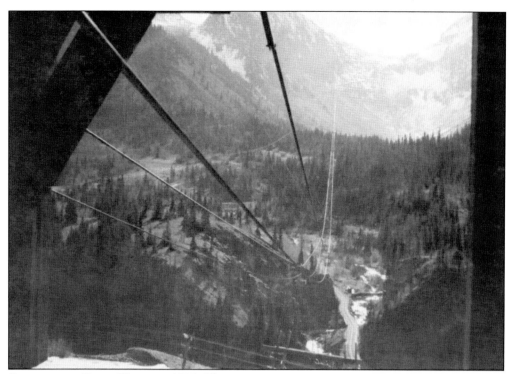

SHENANDOAH-DIVES TRAM, C. 1930. This is the view from tram house at the Shenandoah-Dives Mill looking up the cable into Arrastra Gulch. The shininess of the cable suggests the tram is newly built. The tram was used to bring ore from the Shenandoah-Dives Mine to the mill for processing. This tramway is one of the few still standing in the San Juans Mountains with the cables still in place.

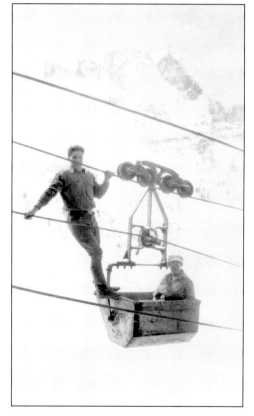

SHENANDOAH-DIVES TRAM BUCKET, 1945. Men were allowed to ride the tram to work at the Shenandoah-Dives. Women rode them as well, like those working in the kitchen or men's wives visiting the commissary. Kids would sometimes ride the tram even though forbidden by management. Silvertonian Gerald Swanson recalled hiking to the boardinghouse as a young boy to get a free lunch in the 1930s and then catching a ride down on the tram. They had to be careful so Charles Chase, the mine manager, would not catch them. The man standing on the bucket is Paul Bingel.

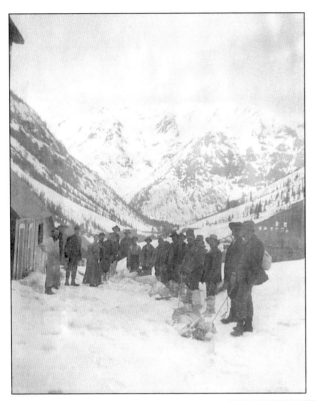

AVALANCHE, 1906. On St. Patrick's Day, 1906, a series of snowslides killed 18 men in San Juan County. Of the 18 men killed, 12 of them were in the boardinghouse at the Shenandoah Mine in Dives Basin. It was about 6:30 p.m., and the men at the Shenandoah had finished supper and were sitting around chatting, smoking, and playing checkers. Suddenly, as the avalanche hit, they were thrown out into the snow. The boardinghouse was swept away as if it were made of straw. The photograph at left shows a rescue party about to take the bodies down Cunningham Gulch to Silverton. The image below is of the camp used in the recovery efforts, and debris from the boardinghouse can be seen next to the tent.

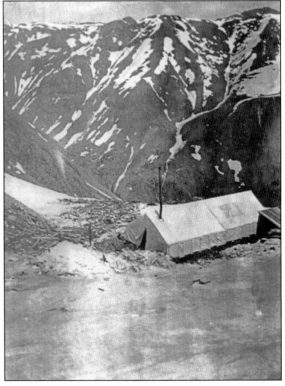

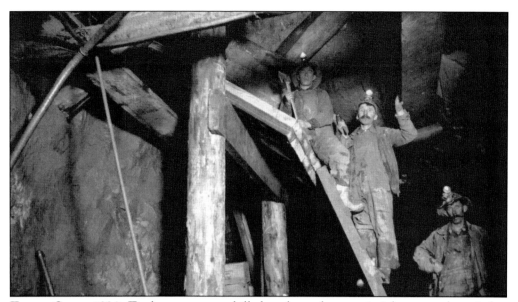

TIMBER CREW, 1930. Timber men were skilled workers whose main job was to place timber supports in the mine workings. This timber crew in the Shenandoah-Dives main level is in the process of building an ore chute. The two men on the ladder are Tony Blazzanella on the top and John W. Prince on the bottom. The third crew member is unidentified.

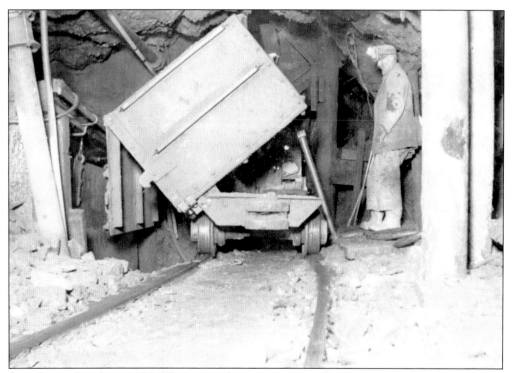

SIDE-DUMP ORE CAR, 1930. This image shows a miner standing next to a side-dump ore car at the Shenandoah-Dives main level ore chute, which delivered ore to a crusher located on a lower level. The miner has a carbide lamp on his cloth cap.

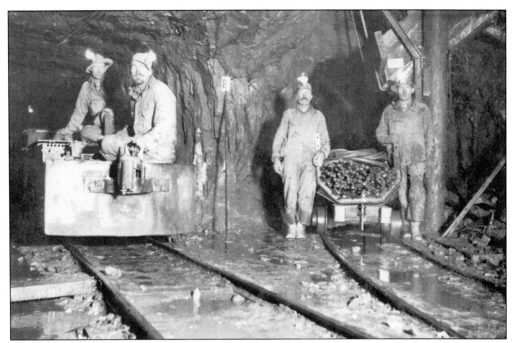

UNDERGROUND SHENANDOAH-DIVES, MAIN LEVEL, 1930. The two trammers on the left are driving a train motor that is probably pulling a string of ore cars. The two nippers on the right (workers who brought supplies and equipment to the miners) have a flat car full of drill steels. None of the men are identified.

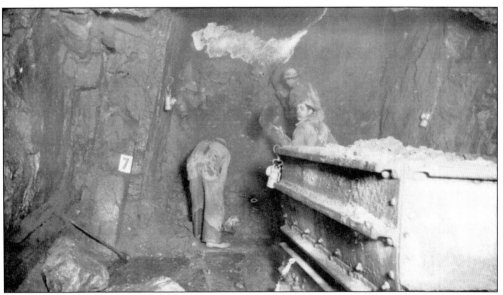

MUCKING, 1930. These three men are mucking (removing) ore from the Mayflower vein on the Shenandoah-Dives main level after a blast. They are loading the muck into an ore car. Note the three hand carbide lamps that provided light.

Four

HOWARDSVILLE

Howardsville was named after George Howard, who built the first cabin there in 1872. He was one of the original Baker Party, and he staked the No Name claim adjacent to the Sunny Side (later changed to Sunnyside). Howardsville is located in the Animas Valley at the mouth of Cunningham Gulch, where a number of mines were located, the biggest being the Old Hundred, Green Mountain, Highland Mary, Gary Owen, and Pride of the West.

By 1874, Howardsville had a post office and was made the county seat of La Plata County. However, in fall of that year, the growing town of Silverton won an election that moved the county seat to Silverton. In 1875, Howardsville had several saloons, an assayer, an attorney, a hotel, a blacksmith, and a brewery, but with the loss of the county seat, it never regained its status as the metropolitan and supply center of the area.

In 1872, three brothers from Germany, Reinhard, Gustave, and Otto Neigold, staked a claim on Galena Mountain that became the Old Hundred Mine. The mine was worked at several levels on the side of the mountain that were connected to the mill in Cunningham Gulch by a tram. Today, the seven level boardinghouse and tram tower can still be seen clinging high on the side of the cliff. Tourists can also take the Old Hundred Gold Mine tour and get a feel for what it was like to work in an underground gold mine.

Scott Fetchenhier's book *Ghosts and Gold* gives a complete history of the Old Hundred Mine.

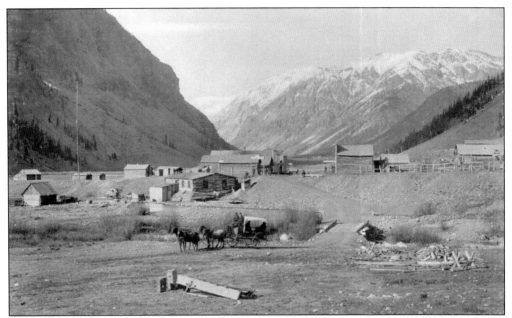

HOWARDSVILLE. A horse-drawn carriage with passengers and two drivers leaves Howardsville sometime in the late 1870s. Even though the town is relatively new, it had its own billiard hall among other businesses. Most of the structures in town are built of logs. The cabin on the far right is still standing today. (Photograph by William Henry Jackson; courtesy of the Denver Public Library, WHJ-1582.)

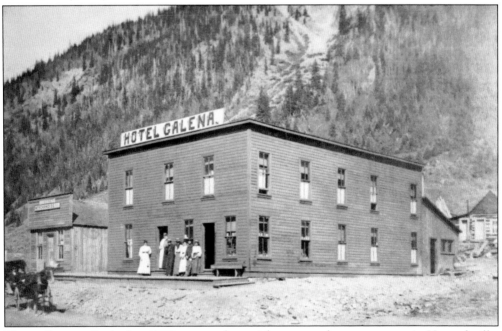

HOTEL GALENA. By the late 1880s, more substantial structures began to appear in Howardsville. The two-story Hotel Galena, located on Main Street, was operated by Eleanor Mock Shaw, who is standing in the doorway. Eleanor's husband and two of their sons were well-known packers in the area. The general merchandise store is located to the left of the hotel.

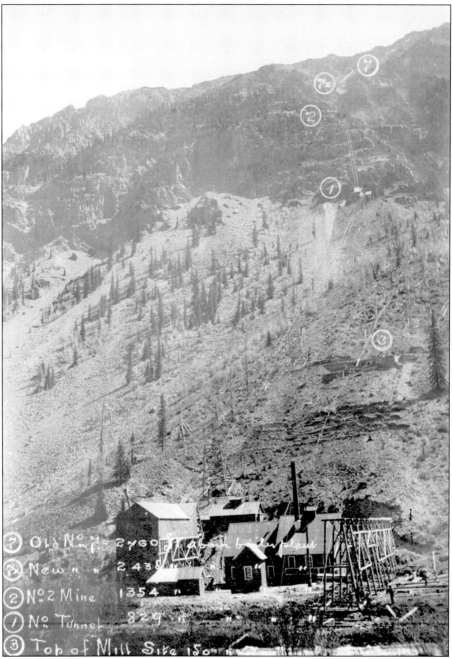

OLD HUNDRED PROPERTY. This view of the Old Hundred property was taken in the fall of 1904 or summer of 1905 from Cunningham Gulch looking at Galena Mountain. Buildings include the tram terminal to the lower left and the boiler plant to the right. Construction of the mill was just beginning, with the top of the mill being located at the number three. Three tramlines connect the various levels of the mine to the tram terminal. Some of the level designations were later changed, such as level two later called level five and 7x was just level seven. Both levels five and seven had boardinghouses and tram terminals. The trestle in the lower right was used to remove rock from excavating the mill foundation. Elevations of each level are given in the legend.

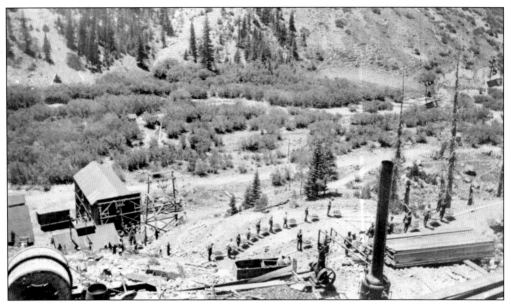

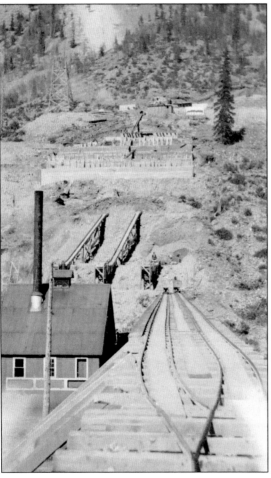

CONSTRUCTION CREW, 1905. During the summer of 1905, work on the Old Hundred Mill began. A line of workmen with wheelbarrows can be seen moving material. In the lower left is a large cement mixer for the concrete needed for the mill foundation. To the right is a boiler attached to a steam engine that drives the cement mixer with a large belt.

MILL FOUNDATION. This image shows the initial construction of the Old Hundred Mill foundation. The boiler house with its stack is located below the mill foundation. Two chutes seen above the boiler house were used to move rock from the mill foundation site down to bins. Ore cars were then filled from the bins and transported across the double-track trestle to be dumped in a pile, which is still there.

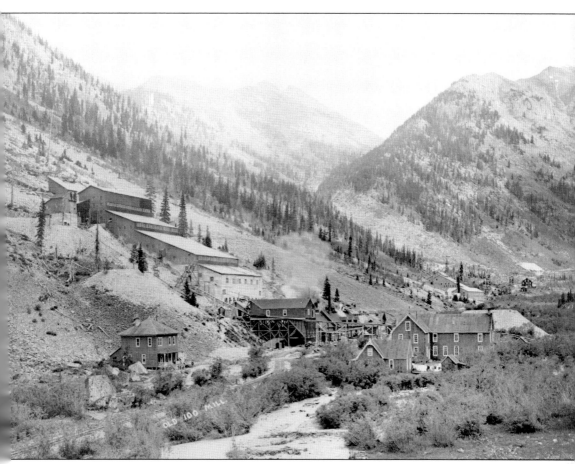

OLD HUNDRED MILL, 1907. This view, looking across Cunningham Creek toward the southeast, shows the entire mill level complex after the mill has been completed. The mill, which climbs up the side of Galena Mountain, had an ore-processing capacity of 200 tons per day. The Old Hundred Mill used 40 stamps to crush the ore. The ore was then passed over concentrating tables to recover the gold. The large building on the right was the boardinghouse that was destroyed by fire at a later date. The square two-story building on the left was probably used for the mine staff. The tracks of the Silverton Northern Railroad lead to the lower level of the mill, where the concentrates were loaded into railcars. The Green Mountain Mill is visible farther up the gulch.

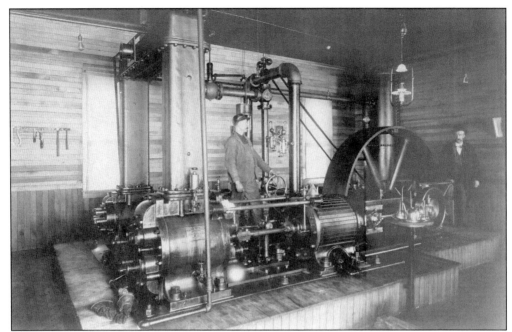

Steam Air Compressor, c. 1906. The Old Hundred compressor plant was located below the mill and consisted of two steam-powered compound compressors (one shown here). The first compressor had the capacity to operate 10 air drills, while the other could operate 20 drills. The total capacity was 3,400 cubic feet per minute.

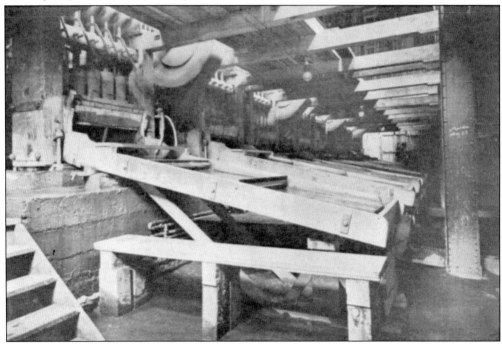

Old Hundred Stamps. The Old Hundred Mill used 40 stamps to crush ore fine enough to process using 18 Card concentrating tables. The mill was able to treat 200 tons of ore per day and was built at a cost of $450,000. (From *The Golden San Juan*, published by the *Silverton Miner*, 1907.)

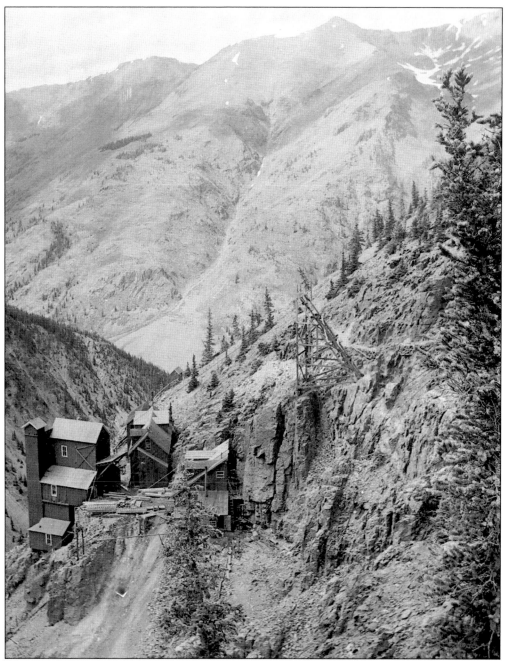

FIVE LEVEL WORKINGS, C. 1906. The five level was approximately 1,300 feet above the mill. The building on the left was the tram terminal, unique in that it served both the tram from above and below. Note the tower toward the upper right of the photograph for the tram to the seven level. The tower on the left side of the tram building was a bucket elevator to transfer coal and materials from the lower tram to the upper seven level tram for moving material uphill. Next to the tram was the boardinghouse. The building with the sloped roof up against the rock wall covered the adit as well as the blacksmith shop. None of these buildings are still standing. This photograph was taken from higher on Galena Mountain looking toward the northwest.

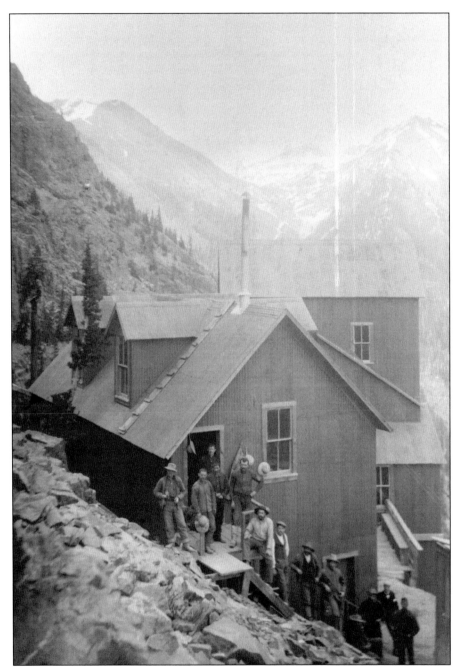

FIVE LEVEL BOARDINGHOUSE. Here, a group of miners are standing on the steps of the boardinghouse at five level seen in the previous photograph. Boardinghouses were necessary because most mines were not located near a convenient town where the miners could live and easily walk to work. Mine boardinghouses were common throughout the West, but no area seemed to have more of them than the San Juan Mountains. This is due mainly to the physical geography of the area. In 1890, H.H. Bancroft described the San Juan Mountains as "the wildest and most inaccessible region of Colorado, if not North America." Another reason for the boardinghouses at the mines is the severe winters, in which annual snowfall can be 15 feet or more.

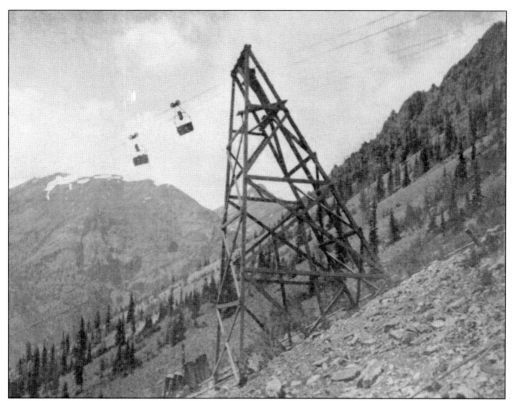

AERIAL TRAM. The Old Hundred tramway was built by the Trenton Iron Works of Trenton, New Jersey, and was a mile in length. Here, two ore buckets are passing near one of the towers that supported the tramline. (From *The Golden San Juan*, published by the *Silverton Miner* 1907.)

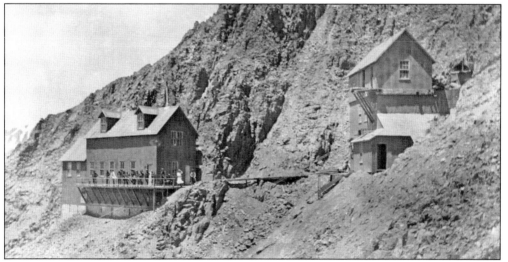

SEVEN LEVEL BOARDINGHOUSE. The Old Hundred seven level also had a boardinghouse (on the left) and a tram terminal (on the right). The mine crew is standing on the boardinghouse porch. The man with the white apron was probably the cook. In recent years, these two buildings have been restored by the San Juan County Historical Society and are still visible clinging to the side of Galena Mountain.

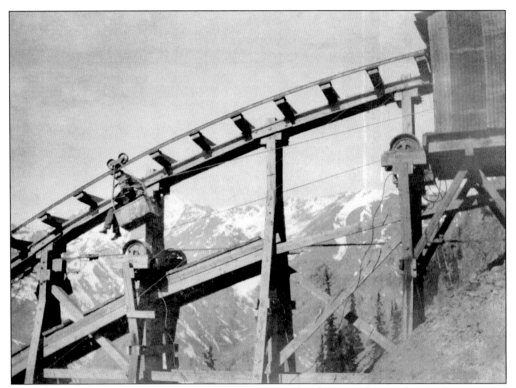

OLD HUNDRED TRAM TERMINAL. This view of the two level terminal was taken looking toward the northwest. It shows an ore bucket leaving the terminal. Note the legs of the man riding in the bucket. Many of the mines allowed men to ride the trams, but some did not.

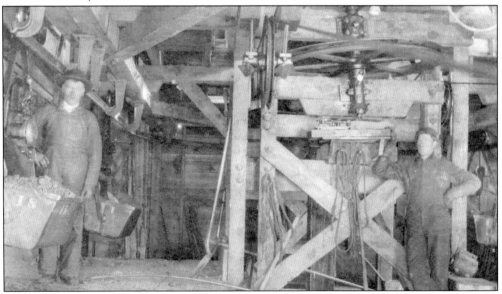

INSIDE OLD HUNDRED TRAM TERMINAL. The inside of the lower tram terminal of two level (later five level) consisted of sheave wheels and an overhead rail to allow removal of the bucket off the cable for loading and unloading. In this scene, two loaded tram buckets are ready to be sent down the tram to the mill by two men manning the station.

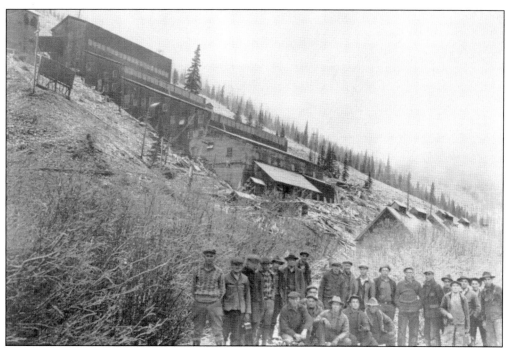

OLD HUNDRED MILL. By 1929, the Old Hundred property came under the control of the Dresser Mining Company. The new owner revamped the mill and also purchased the nearby Gary Owen Mine. These two views show the mill in 1929. The above photograph was taken in an easterly direction and shows the crew that possibly was revamping the mill (note ladders on the side of the mill). The photograph below of the mill shows the entire mill complex. The tram terminal on the left is for the Old Hundred Mine, and the terminal on the upper right of the mill is for the Gary Owen Mine. The surface tram on the right, which leads from the loading dock on the railroad tracks up to the Gary Owen tram terminal, was used to transport material bound for the mine.

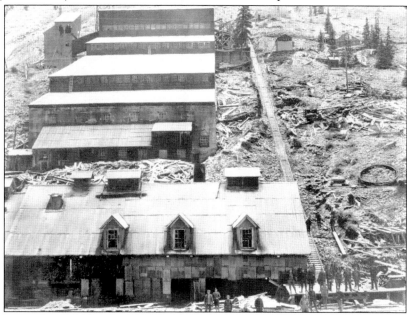

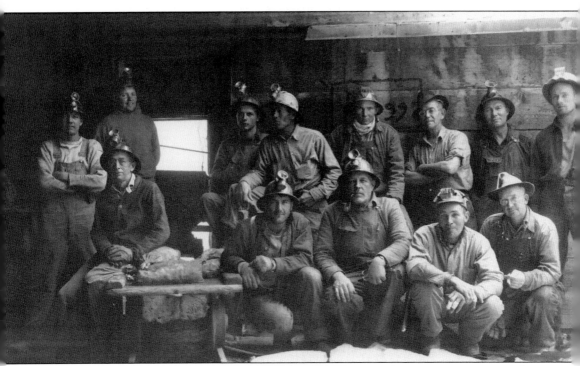

SAMPLING CREW, SUMMER 1939. In the summer of 1939, a sampling crew spent a month living and working at the seven level of the Old Hundred Mine. The crew, under the direction of mining engineer H.W.C. Prommel, sampled the upper workings of the mine to determine if there was enough ore to warrant further mining. The crew members pictured here are, from left to right, (first row) Ben F. Webster Jr., Joe Perlman, H.W.C. Prommel, Virgil Henry, and Art Walker; (second row) Ernest Dissler, Harold H. Prommel, William Manning, Louis Bush, Glenn Nelson, Jerry "Murph" Murphy (cook), Martin Pulliam, and Walter S. Kimball. Living conditions for the crew were difficult. In the 1950s, Jack Foster of the *Rocky Mountain News* hiked to this boardinghouse and found a message penciled on the wall left by this sampling crew in 1939. It read, "This is hell. We started to heaven and landed square in hell."

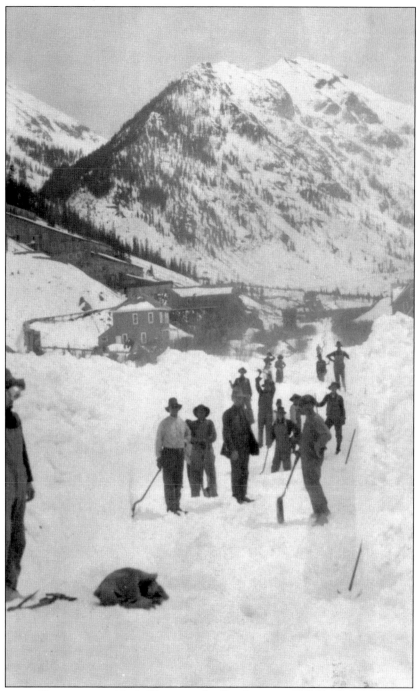

CLEARING THE RAILROAD, C. 1916. Winter in the San Juans was a difficult time for the railroads to operate. Huge snowstorms and snowslides would close the tracks for days or even weeks on end, requiring large crews of men with shovels to clear them. Mine workers were sometimes hired to help shovel. The crew is clearing the tracks of the Green Mountain Branch of the Silverton Northern Railroad that served the Old Hundred Mine, seen on the left, and the Green Mountain Mine, farther up Cunningham Gulch.

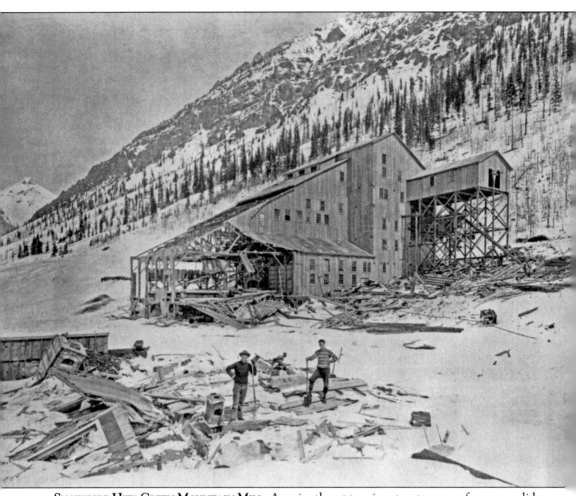

Snowslide Hits Green Mountain Mill. A major threat to mine structures was from snowslides, or avalanches. With an annual snowfall of 15 feet or so, the high, steep San Juans have been called the greatest country in the world for snowslides. The winter of 1905–1906 was probably the worst in terms of loss of life and destruction of property. On St. Patrick's Day, Saturday, March 17, 1906, a series of snowslides killed 18 men in San Juan County. Some places in Cunningham Gulch were covered by as much as 150 feet of snow. The snowslide hit the Green Mountain Mill and totally destroyed the assay office building in the foreground. The assayer was found alive in the ruins after two hours. This view is northeasterly down Cunningham Gulch, with the ruined mill and Galena Mountain in the background.

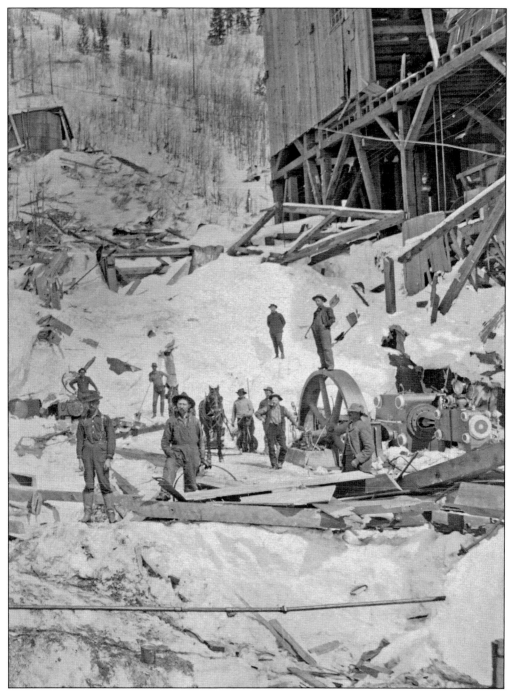

Destroyed Boiler Section. Here is another view of the Green Mountain Mill in Cunningham Gulch, which was hit by a snowslide on St. Patrick's Day in 1906. Among the debris is the large Corliss engine. The man on the right is standing on the engine's large flywheel. This crew is in the process of removing debris and snow from the avalanche. The horse in the background appears to be pulling a scraper to remove snow from what remains of the structure. The man in the foreground has a large saw at his feet to cut up large pieces of wood.

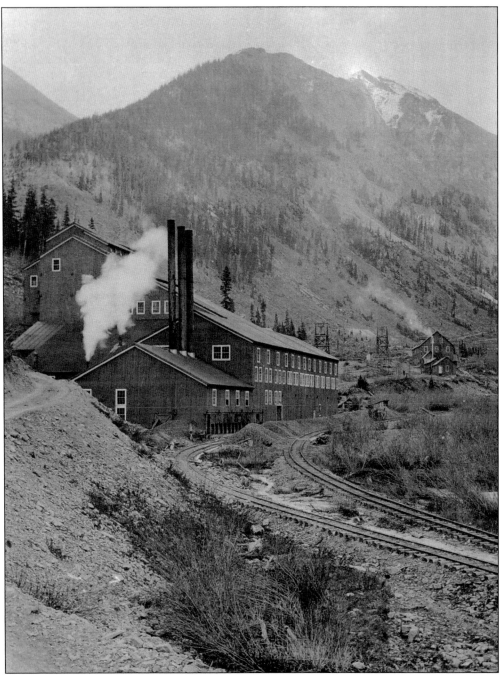

GREEN MOUNTAIN MILL, C. 1906. The Green Mountain Mill was located 1.5 miles up Cunningham Gulch from Howardsville and was quickly rebuilt after the St. Patrick's Day avalanche. It was a well-equipped concentrating mill of 100 tons daily capacity. The new boiler section of the mill with three large stacks can be seen in the foreground. The main line and a spur track of the Silverton Northern Railroad passed in front of the mill. Beyond the mill is the Bleichert tramway used by the mine, and the Green Mountain boardinghouse is to the right. Green Mountain is in the background.

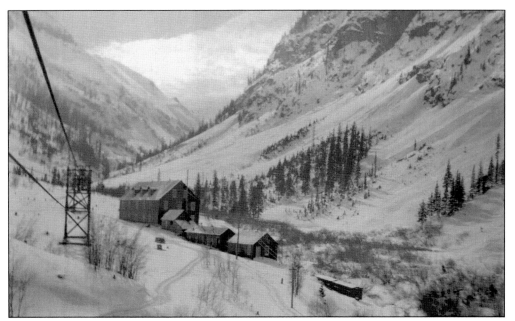

GREEN MOUNTAIN BOARDINGHOUSE C. 1906–1907. The large three-story structure seen here is the Green Mountain boardinghouse. The kitchen, storehouse, and living rooms were on the first floor. The second floor was divided into rooms for the employees of the mine and mill, and the whole building had steam heat. The assay office and manager's office were located in the buildings to the right of the boardinghouse.

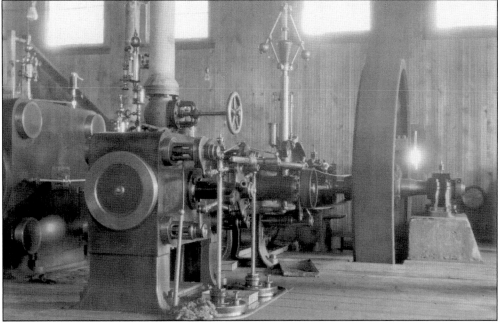

GREEN MOUNTAIN MILL INTERIOR, C. 1906–1907. The Green Mountain power plant consisted of a Corliss tandem-compound 150-horsepower engine, a low-pressure 85-horsepower Corliss engine, a Pelton water wheel, and a Westinghouse electric dynamo for lighting the mill, mine, and boardinghouse. This image shows one of the Corliss engines in the mill.

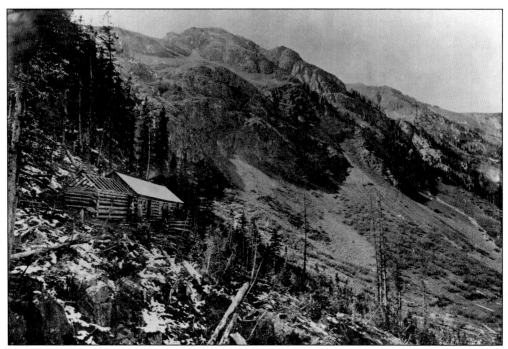

HIGHLAND MARY MINE. John Dunn, Andrew Richardson, and William Quinn located the Highland Mary Mine in 1874. One of the earliest boardinghouses in the San Juans was at the Highland Mary, seen in the above photograph taken in 1875 or 1876. The woman in the photograph is probably Susan Eaton, who was the cook at the mine. The 50-ton Highland Mary Mill seen in the photograph below (c. 1910) was built in 1902. The mine was last operated in 1952 and over its long history had a profit of about $3 million. (Above, courtesy of the US Geological Survey.)

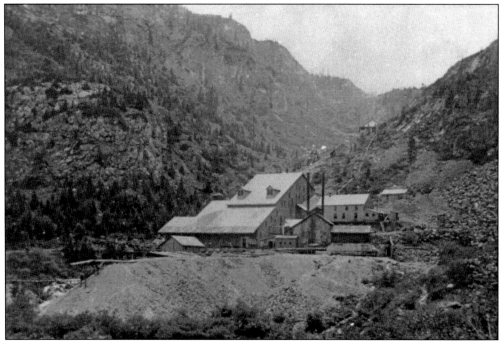

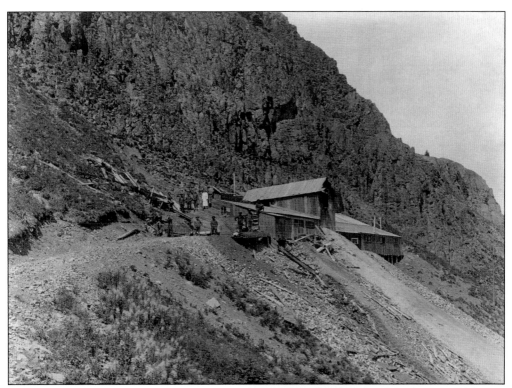

TRILBY MINE, 1909. Next to the Highland Mary Mine on King Solomon Mountain was the Trilby Mine. This photograph, taken from the trail to the mine, shows the portal and surface buildings. A number of men are posing outside the mine, and the men on the left are demonstrating double-jack drilling. A little girl is sitting on the porch; the man dressed in white is probably the mine's cook.

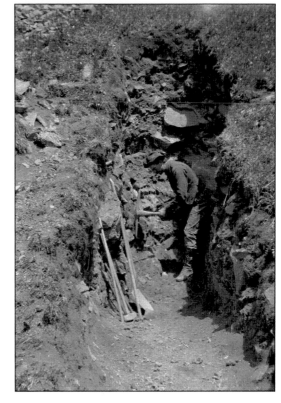

HOOT MON LODE. Minnie Gulch is located between Howardsville and Eureka and serves as the location of several mines. On August 3, 1915, George D. Brown was working his discovery cut of the Hoot Mon lode in Minnie Gulch. This was a typical scene throughout the San Juans, with most prospects never amounting to much.

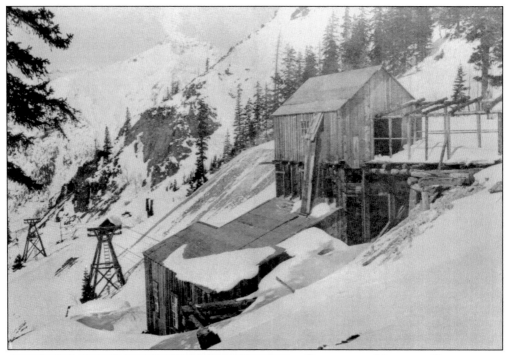

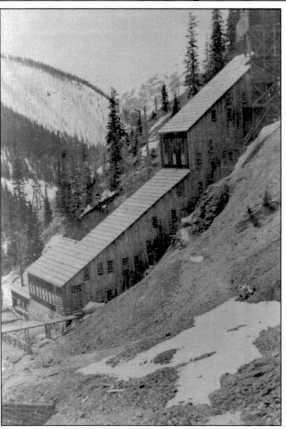

CALEDONIAN MINE AND PEERLESS SAN JUAN MILL. The Caledonian Mine, with a tram running to the Peerless San Juan Mill, was another prospect in Minnie Gulch that did develop into a working mine. The above photograph shows portal structures and the upper end of the tram. The tram towers lead to the mill seen in the photograph at left. The Caledonian Mine was one of the few mines unaffected by the Spanish flu outbreak of 1918. The mine did not allow its workers to go to town during the outbreak, and no new men were allowed on the property. As a result, no one at the mine contracted the flu, and work continued normally. The photograph at left is of the Peerless San Juan Mill.

Five

GLADSTONE

The town of Gladstone, Colorado, was located along Cement Creek about eight miles upstream from Silverton. It was named after William Ewart Gladstone, who served as British prime minister four separate times in the 1800s. Although Gladstone never grew beyond the mining-camp stage, it was a settlement that supported two major mining companies in the area, the Gold King Consolidated Mines Company and Mogul Mining Company.

The Gold King Mine was discovered in 1887 by a miner named Olaf Nelson, and by 1900, the Gold King Consolidated Mines Company had been formed to work the property. This mining company also owned other claims in addition to the Gold King as well as over 1,200 acres of coal land in the Durango area. It also built and controlled, for a time, the Silverton, Gladstone & Northerly Railroad, which ran from Gladstone to Silverton. This railroad made its first run to Gladstone from Silverton on August 4, 1899.

The other major producer near Gladstone was the Mogul Mine. This company was privately held and therefore released little information about itself, not having to impress potential investors. About 1905, the company began construction of a state-of-the-art mill to process its ore. This mill was abandoned by the late 1930s, and the town of Gladstone was on the decline. By 1945, Gladstone was virtually gone.

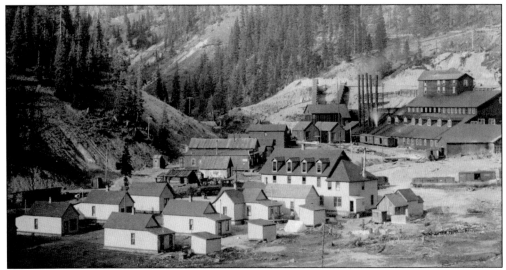

GLADSTONE, EARLY 1900s. Gladstone was located near the head of Cement Creek and developed to meet the needs of two mines in the area, the Gold King and the Mogul. The large Gold King mill stands on the right in this photograph. The large three-story boardinghouse known as the Gold King Hotel (white building with dormer windows) stands behind a number of company houses of the Gold King Mine. Gladstone's small business district is located to the left of the hotel. In 1903, the business district consisted of two saloons and a general store.

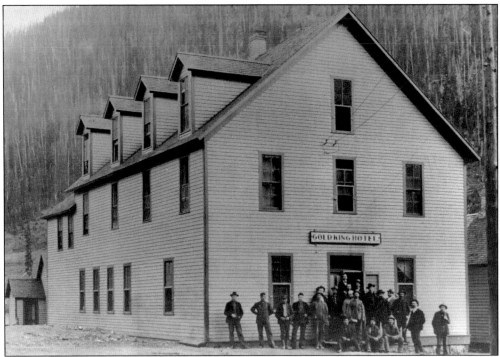

GOLD KING HOTEL. This group of men is standing outside the Gold King Hotel that is seen in the previous photograph. This three-story building had a front gable, dormers, and clapboard siding and was used by the Gold King Mine as a boardinghouse for its employees. In 1905, there were 40 men working in the Gold King Mill, and many of them probably boarded here.

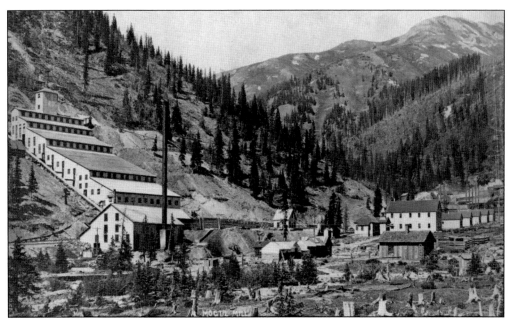

MOGUL MILL, 1906. Construction of the Mogul Mill began in 1905. The Mogul Mill was located on the north edge of Gladstone at the base on Red Mountain No. 1. The large tower at the top of the mill was the tram terminal where ore buckets from the mine entered the mill. The boiler plant is the building with the single stack. Gladstone had its own school with a bell tower that is just right of center in this photograph.

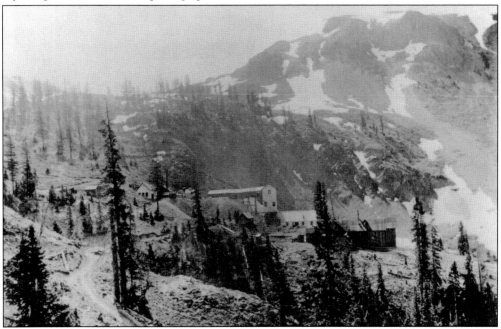

MOGUL MINE, C. 1907. About 1900, James Dempsey and a group of Eastern capitalists acquired 15 claims in Ross Basin that became the Mogul Mine. The ore was of low grade, but the veins were among the largest in the district, making the mine profitable. (Courtesy of the Denver Public Library, X-62227.)

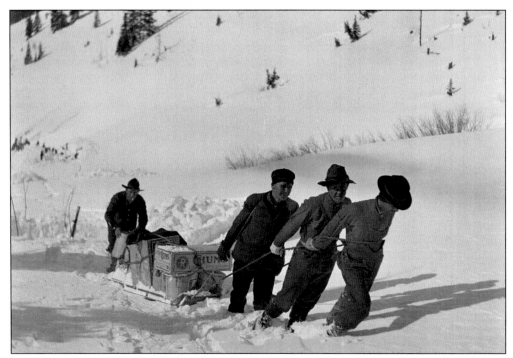

WINTER SUPPLIES. Even though the Silverton, Gladstone & Northerly Railroad served Gladstone, snowslides would often block the tracks, preventing trains from delivering supplies. In these times, residents of Gladstone had to be resourceful. These two photographs were taken during the snow blockade in February 1909. The above image shows three men pulling and one pushing a toboggan full of boxes. From left to right are J. Bennett, J. Sullivan, Frank Wurtz, and unidentified. The image below shows two men pulling a toboggan with a load of meat.

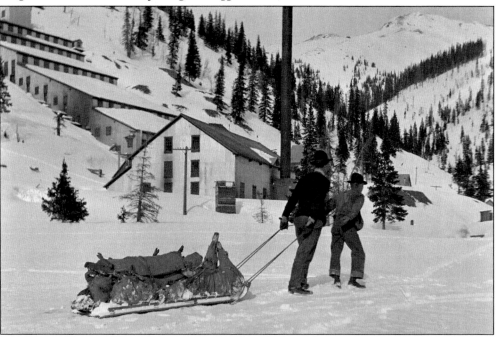

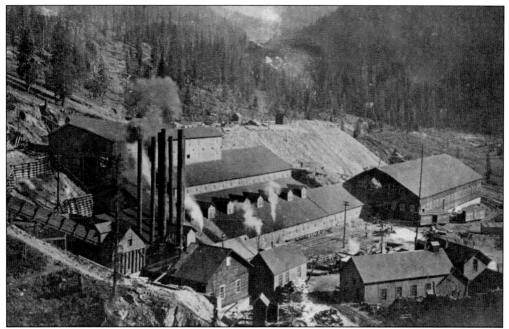

GOLD KING MILL, 1906. This view looking down on the Gold King Mill shows virtually all of the buildings in the mill complex. The mill had a daily capacity of 400 tons, producing 50 to 60 tons of concentrate. The building with the large smokestacks housed the boilers and generating units. Directly behind that is the multilevel ore house and stamp mill, with its 80 stamps and various concentrating tables. The large gable-roofed building on the right housed an additional 20 concentrating tables.

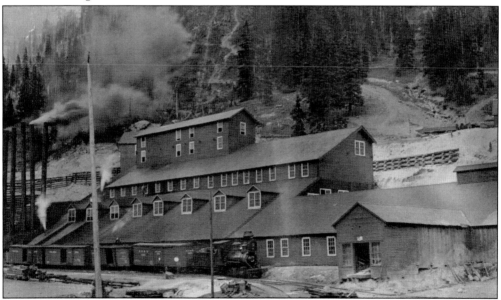

GOLD KING MILL, C. 1901. Silverton, Gladstone & Northerly locomotive No. 32 stands in front of the Gold King Mill with four boxcars that are in the process of being loaded with concentrates. The clearing in the trees above the mill is for the cable tramway that leads from the ore house at the mill to the mine above on Bonita Mountain.

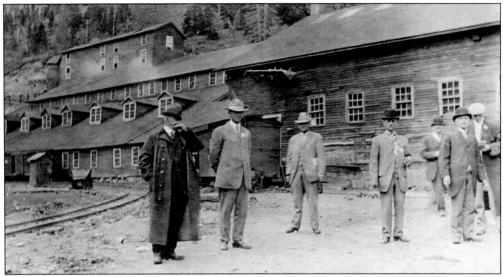

OTTO MEARS, C. 1910. This group of civic leaders and investors are touring the Gold King Mill in Gladstone at the terminus of the Silverton, Gladstone & Northerly Railroad tracks. Included in the group was Otto Mears, second from the right, who in 1910 leased the Silverton, Gladstone & Northerly Railroad. In 1911, Mears also leased the Gold King Mine, and the following year, high-grade gold ore was discovered. Six to eight boxcars of ore were shipped per day. The second man from the left is Mear's son-in-law James R. Pitcher, who was managing Mear's railroads.

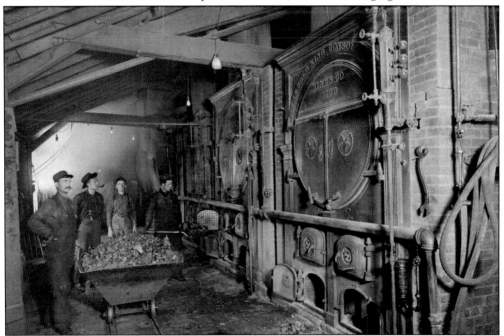

BOILER ROOM, 1906. A large amount of coal was needed to power all the machinery in a mill. Three men pose for this photograph that was taken in the Gold King Mill boiler room while another shovels coal. Working here was dirty work and could be hot even in the dead of winter. The boiler tanks bear ornate ends, with the wording "the Gold King Consolidated Mines Co., 1900/Star Boiler Works."

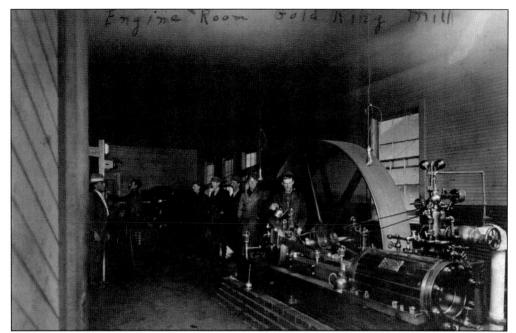

ENGINE ROOM, 1906. The engine room at the Gold King Mill had to be kept clean due to the oiled machinery. The man on the right is keeping the stationary steam engine well oiled. The large belt from the engine powered the electric generator in the rear of the room. The man seated on a stool to the left appears to be at a control panel. All the mine workings and the mine and mill buildings had electric light.

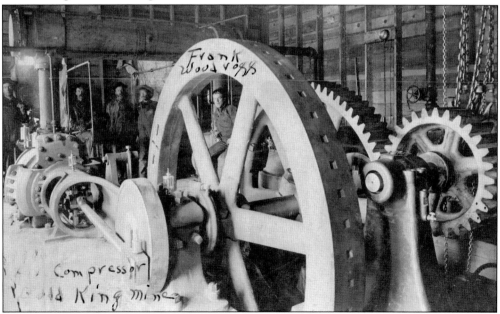

COMPRESSOR ROOM, 1906. This view taken inside the compressor room at the Gold King Mine (probably at the seven level) shows all the wheels, gears, pistons, valves, chains, and other machinery and equipment involved. Compressed air was needed to power all the rock drills underground. The man on the right is likely Frank Woodruff.

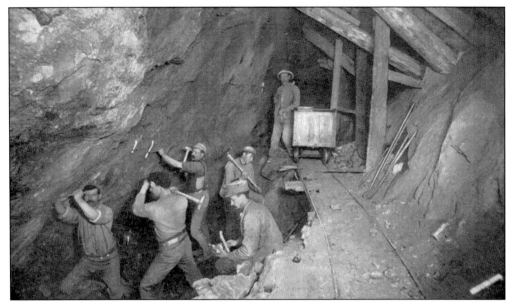

GOLD KING STOPE, 1899. A stope is an excavation in a mine where ore has been removed. In this view, miners are working an underhand stope in the Gold King Mine. Ore was mined overhead, while waste rock was allowed to build up at the bottom of the stope to provide a working surface. In this staged scene, miners are demonstrating hand-drilling. Timbers were needed to support the upper part of the stope, and the only light for working was provided by candles. (Courtesy of William R. Jones.)

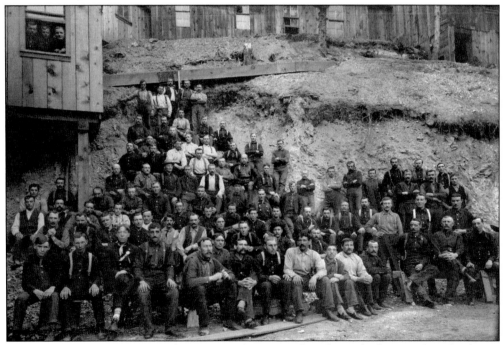

GOLD KING MINERS, C. 1911. A large group of miners gathered outside the mine boardinghouse for this photograph about 1911. This is about the same time that Otto Mears began leasing the mine.

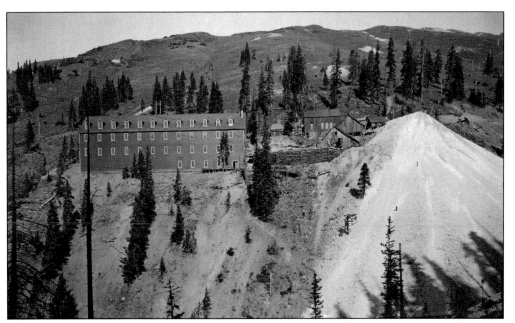

GOLD KING BOARDINGHOUSE, 1906. The Gold King Consolidated Mines Company built a large four-story boardinghouse for its workers at the seven level mine workings. The boardinghouse was capable of accommodating 160 men. The tram terminal is located to the right of the boardinghouse above the cribbing. Tram cables can be seen leaving the terminal on the right. In 1908, this boardinghouse burned and was hit by an avalanche.

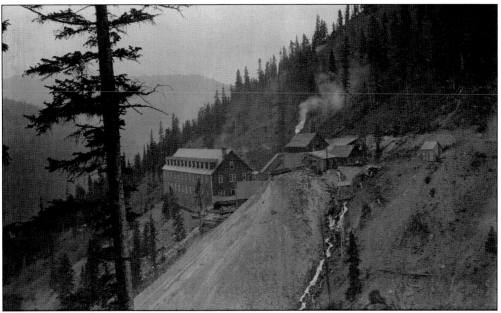

GOLD KING MINE. Here is another view of the Gold King Mine boardinghouse taken shortly after 1910. A covered walkway leads from the boardinghouse to the building at the mine entrance, allowing miners access to the mine without going outside in the winter. What looks like an outhouse in the lower right is built over a stream cascading down the mountain, providing "natural plumbing."

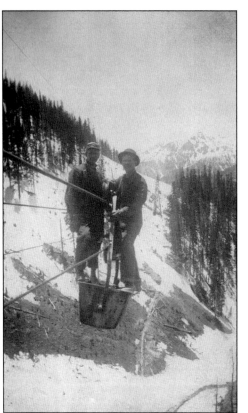

GOLD KING TRAM. The tramway connecting the Gold King Mill in Gladstone with the seven level mine workings was built in 1899 and was approximately 6,000 feet in length. Men would ride the ore buckets to get from Gladstone to the mine. Bob Linden recalled in 1899 that riding the tram to the mine "produces a creepy feeling to the stoutest heart."

AMERICAN TUNNEL FLYER AND CREW. In 1900, the Gladstone Tunnel started from just above the Gold King Mill (2,000 feet below the Gold King Mine) and was to extend 3,000 feet to provide access to the mine workings from below. This would allow for more economical mining as well as better drainage. Note the candles that were poked through the sides of old tin cans to make crude lamps known as shadow-gees. (Courtesy of Tom Rosemeyer.)

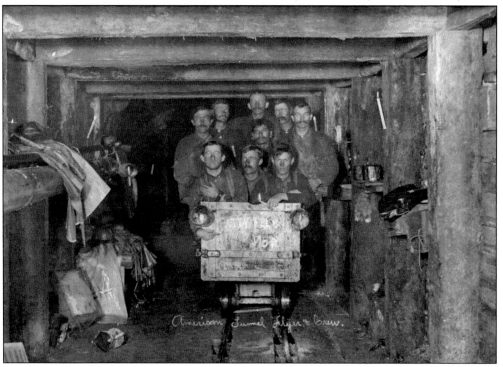

Six

MINERAL POINT

The town of Mineral Point, originally called Mineral City, was located at the headwaters of the Animas and Uncompahgre Rivers in northern San Juan County. Charles McIntyre and Abe Burrows prospected the area in 1873, and several cabins were built at that time. Mineral Point sits on a quartz knob that gives the town its name and became the supply point for the surrounding mines. Mining engineer David W. Brunton, in 1875, recalled the "alleged city had an altitude of 11,700 feet and contained a motley assortment of tents, together with a few poorly-built log cabins. The rain-fall was so great and flurries of snow so frequent that a tent was far from being comfortable." Mineral Point never grew larger than a handful of cabins, a post office (which may have been the highest in the country), general store, hotel, and a couple of saloons. Some of the most prominent mines in the area included the Red Cloud, Ben Butler, Bill Young, Uncompahgre Chief, San Juan Chief, Mastodon, and Polar Star Mines, but most of them never amounted to much.

Other mines lay just to the west near Lake Como and Poughkeepsie Gulch. Among these were the Old Lout, Alaska, Saxon, and Bonanza Mines. The area saw a flurry of excitement when Leadville's silver millionaire Horace Tabor purchased several properties at the head of Poughkeepsie Gulch, including the Alaska Mine. He toured the area in 1879 and described his claims as "worth nearly or about the same now, I suppose, as my interests in Leadville." Unfortunately, the Alaska Mine never measured up to Tabor's expectation of becoming another Little Pittsburg or Matchless Mine.

The Damschroder family's Manhattan mining claim in Poughkeepsie Gulch was like hundreds of small mining claims scattered throughout the San Juans. The series of images shown here from the Norman Damschroder Collection give a unique look into the working of a small mining operation.

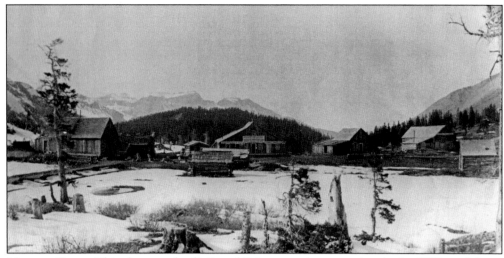

MINERAL POINT. This photograph of Mineral Point was taken sometime in the 1880s and shows the main part of the settlement in the winter. The White and Harvey General Store is in the center. A portion of the Uncompahgre Range is in the background, and the valley beyond the buildings is Mineral Creek Gulch.

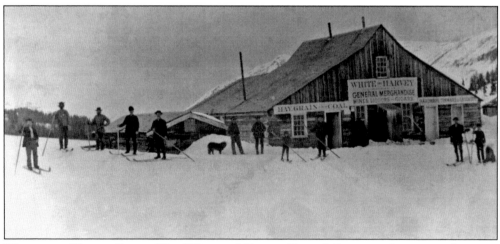

WHITE AND HARVEY STORE. The White and Harvey General Store was the center of activity of Mineral Point. According to the signs, groceries, tinware, hardware, hay, grain, coal, wines, liquors, and cigars could all be purchased at the store—everything a miner would need. Most of the men in front of the store are on skis.

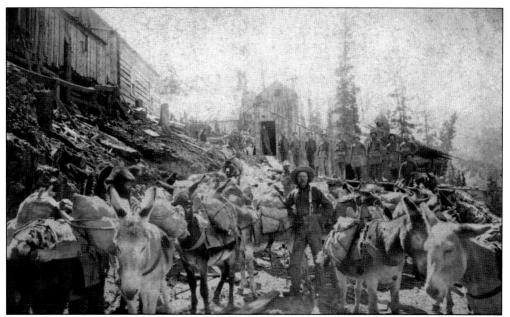

OLD LOUT MINE, C. 1890. The Old Lout Mine was located in 1876 and named after Oliver K. Loutzenhiser. It was one of the best producers in the Mineral Point area, and the mine's production in the first month was worth $86,000. In the foreground is Merrill Doud and a pack train of burros loaded with bags of ore. The mine crew and buildings are behind.

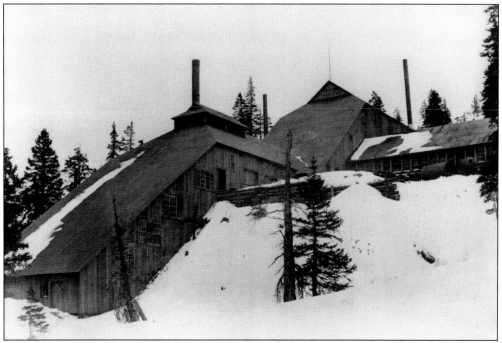

SAN JUAN CHIEF MILL. The San Juan Chief Mill is located a quarter of a mile northeast of Mineral Point and was built in the 1890s to concentrate ores from the San Juan Chief Mine. The upper portion of the mill contained 15 stamps, and the lower portion had a series of wooden vats. Even though the mill is in ruins, the stamps and vats can still be seen.

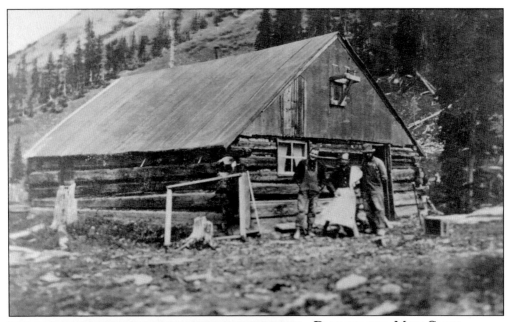

DAMSCHRODER MINE CABIN, 1915. This is the cabin on the Manhattan mining claim, located in Poughkeepsie Gulch, owned by Elmer and Cid Damschroder. This claim was typical of the many small mining operations in the San Juan Mountains. The three men are not identified, but the man in the center is probably the cook.

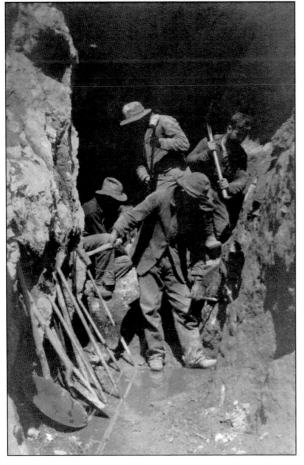

MANHATTAN CLAIM, 1915. The photograph of the open cut at the Manhattan claim is posed, with one man single-jacking, a pair double-jacking, and another wielding a pick. A variety of mining tools is in evidence, including gold pan, shovel, and hand-drill steels. The man with the pick is John Schroeder.

SINGLE-JACKING, 1915. This man, probably Elmer Damschroder, demonstrates the process of single jack hand-drilling on a vein in the open cut at the Manhattan claim. The lone miner uses a four-pound hammer in one hand to hit the drill steel held in the other. After each hit, the miner turns the steel an eighth turn. The steels were round or octagonal rods of various lengths with a chisel tip.

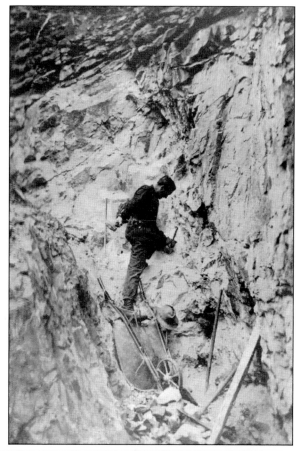

HAND-SORTING ORE, 1915. These two unidentified men are working on hand-sorting ore on the Manhattan claim in Poughkeepsie Gulch. High-grade ore is being placed in gunnysacks, which are then stockpiled for transport to a mill or smelter. Note the metal funnel that is being used to hold the sack open. The man in the back is sewing the top of the sack together to keep the ore in.

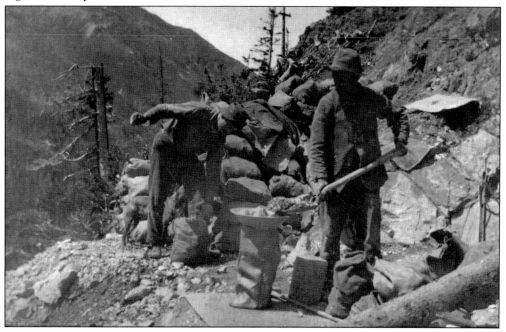

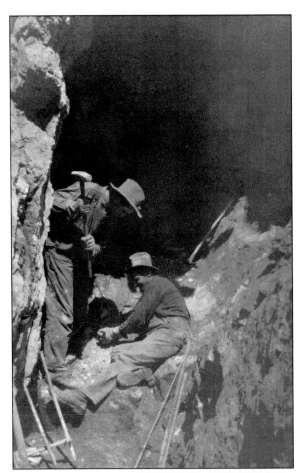

DOUBLE-JACKING, 1915. These two unidentified men are double-jacking in the same cut on the Manhattan claim. In this case, one man holds the drill steel and turns it after each hit while the other strikes the steel with an eight-pound hammer. The two men had to trust each other, since a slight mistake could crush the hand of the miner holding the steel.

BLACKSMITH SHOP, 1915. Even the smallest of mining operations needed a blacksmith shop to sharpen the drill steels every day and make minor repairs of equipment. This is the blacksmith shop at the Manhattan claim in Poughkeepsie Gulch. Cid Damschroder is on the left, with Elmer Damschroder at the anvil.

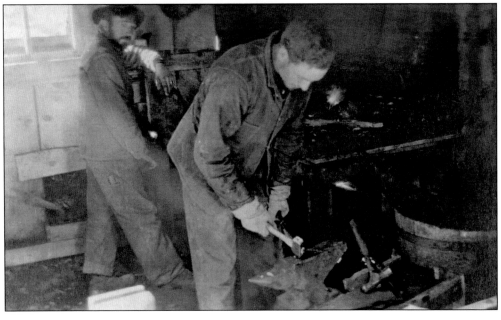

RABBIT HUNT, 1915. This is Elmer Damschroder returning to his Manhattan claim cabin from a rabbit hunt, with a rifle over his right shoulder and his kill in his left hand. Hunting provided a diversion from the toil of mining as well as fresh meat for the larder.

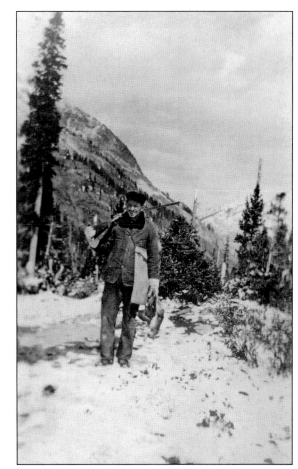

CARD GAME, 1915. Card playing and smoking were common pastimes for miners during the evening. Popular card games included hearts, euchre, and even bridge. The family referred to this cabin at the Manhattan claim as the "bungalow." The men in the photograph are, from left to right, Bill Woessner, Wally Schott, John Schroeder, and Cid Damschroder.

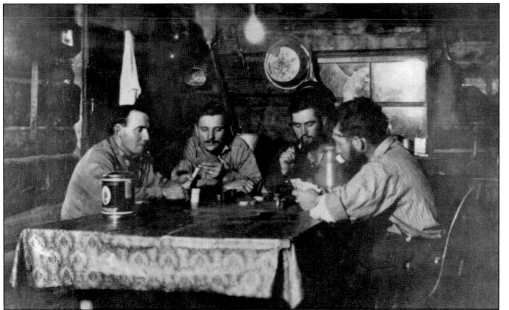

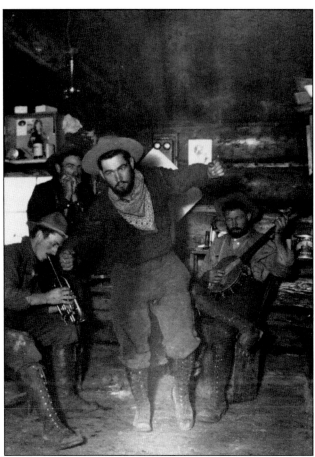

MUSICAL SESSION, 1915. Music and dancing were other ways for the miners to pass the evenings. These four men in the Manhattan claim cabin are Wally Schott (trumpet), Elmer Damschroder (harmonica), John Schroeder (dancing), and Cid Damschroder on (banjo). Note that even at this remote location, the cabin had electricity (light bulb hanging from ceiling) and a telephone on the wall.

PACK TRAIN, 1915. Pack trains were the only way to transport supplies and ore to and from the Manhattan claim. In this photograph, burros are loaded with crates of supplies. The pack train servicing the Damschroders' claim and cabin in Poughkeepsie Gulch was operated by John Donald, and he may be the man on the horse. John Donald had a packing and freighting business out of Ouray.

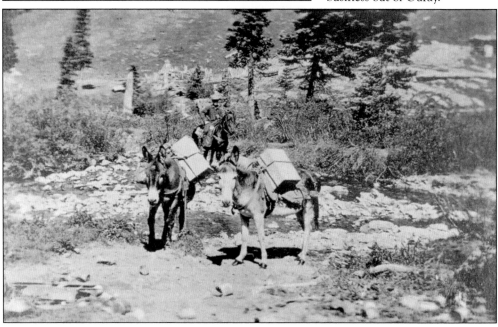

Seven

ANIMAS FORKS

Founded in 1873, the town of Animas Forks was a lively place in the late 1870s and throughout the 1880s. It was located 14 miles north of Silverton at an elevation of about 11,300 feet. The town newspaper, the *Animas Forks Pioneer*, claimed to be the highest newspaper in the United States. There were a number of other businesses in town, which in 1882 included a livery stable and blacksmith, general store, barbershop, laundry, drugstore, meat market, hotel and restaurant, and saloons.

The Silverton Northern Railroad was extended from Eureka to Animas Forks in 1904, greatly improving the transportation situation. Completion of this extension was no easy task, as the railroad climbed over 1,200 feet in 3.5 miles. It was so steep that only two loaded freight cars could be brought up from Eureka at a time. Between 1904 and 1910, Animas Forks experienced a boom period, due to the coming of the railroad and the construction of the enormous Gold Prince Mill and tramway. However, when the Gold Prince Mine closed in 1910 and the mill was moved to Eureka in 1917, the boom was over, and the town was abandoned by 1923.

Among the mining properties near Animas Forks were the Gold Prince (the largest), Frisco Tunnel, Mountain Queen, Sound Democrat, and Vermillion.

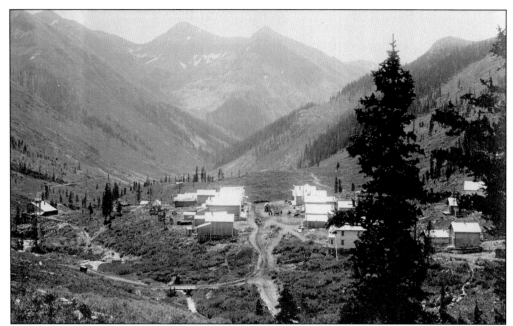

ANIMAS FORKS, 1888. Animas Forks had the appearance that many people think a mining camp should look like: a single main street with some cabins spread around. Animas Forks had a general store, saloon, drugstore, hotel, school, and jail. The structure on the far left was the Greenleaf Mill.

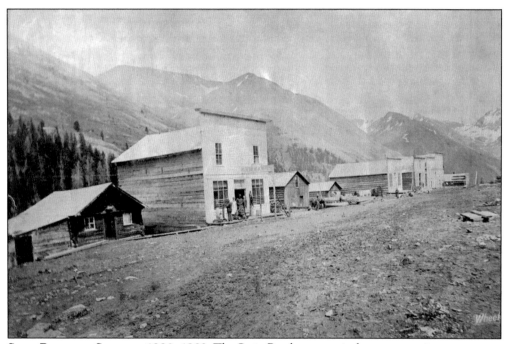

STEIN BROTHERS STORE, C. 1880–1883. The Stein Brothers store is the most prominent structure in this scene. Frank and Wilhelm (William) Stein started their Animas Forks general merchandise store in 1879. The boy in front of the store is Willie Stein.

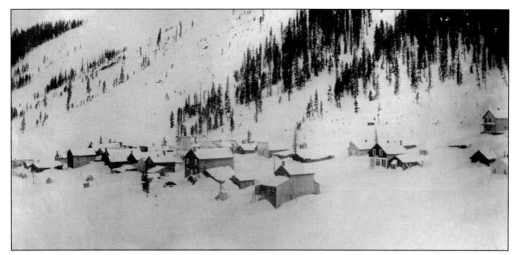

ANIMAS FORKS IN WINTER, 1880S. Situated at an elevation of 11,300 feet, Animas Forks received more that its share of snow, with snowdrifts as much as 25 feet deep. The town was often cut off from the outside world by avalanches that closed trails, and in later years, the railroad.

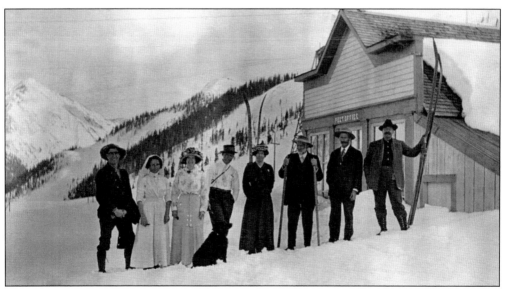

RESIDENTS OF ANIMAS FORKS. Most residents of Animas Forks left town for the winter. The caption for this photograph reads, "Total population of Animas Forks April 1, 1914." By this time, the Gold Prince Mine had closed (in 1910), and the town's population dwindled.

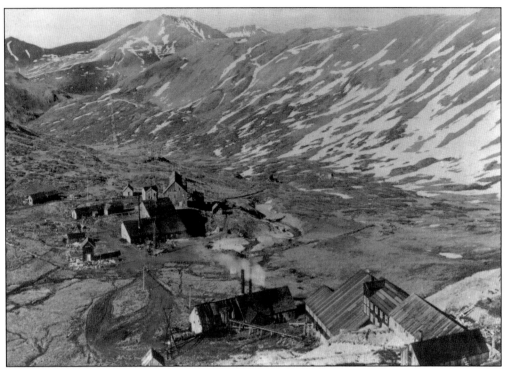

GOLD PRINCE MINE. The Gold Prince Mine was located in Mastodon Basin at the head of Placer Gulch. The Gold Prince, originally known as the Sunnyside Extension, was acquired by the Gold Prince Mines Company in 1903. This view is looking down on the Gold Prince Mine and shows the boardinghouse, tram, and mill, all situated above timberline.

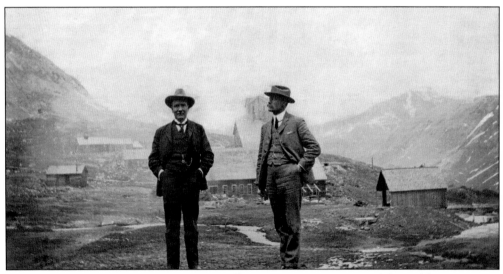

WILLIS Z. KINNEY. The man on the left is Willis Kinney, mine manager of the Gold Prince Mine, who also had been the mine manager of the Gold King Mine. Kinney posed for this photograph, along with an unidentified man, on June 10, 1904, in front of the Gold Prince Mine workings in Mastodon Basin. (Courtesy of History Colorado, CHS.X7701.)

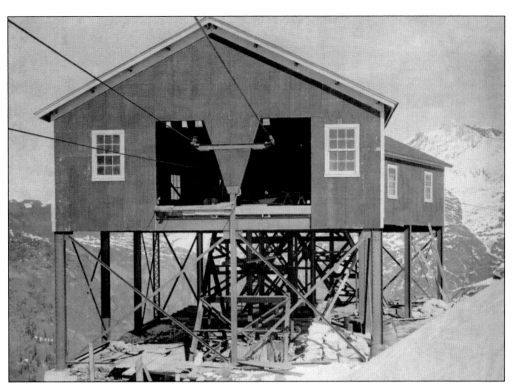

GOLD PRINCE ANGLE STATION, c. 1904–1910. The Gold Prince Mines Company built a 12,600-foot tram at a cost of $75,000 to connect the mine to the mill in Animas Forks. Angle stations were needed when the tramline made an abrupt change in direction. (Courtesy of History Colorado, CHS.X7727.)

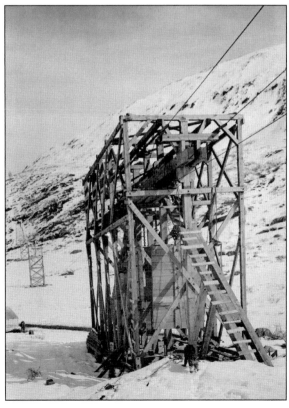

GOLD PRINCE TENSION STATION. Tension stations were used on aerial tramways to keep the stationary cables tight. The cables were cut and attached to weighted boxes of rock (note wooden boxes hanging inside the tower). Tension stations were placed every quarter to half mile depending on the terrain and weight carried. (Courtesy of History Colorado, CHS.X7703.)

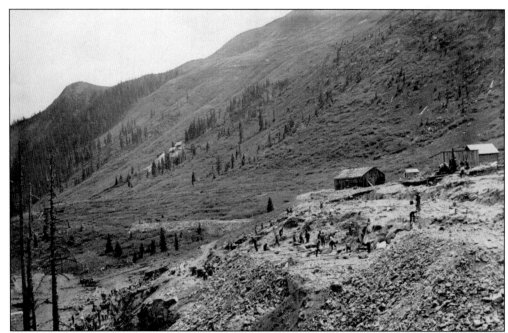

GOLD PRINCE MILL FOUNDATION, 1905. In 1905, Willis Kinney, manager of the Gold Prince Mine, began construction of a 500-ton-per-day mill at Animas Forks. Here, a large crew of men is excavating the foundation for the mill. Workers are seen using wheelbarrows and ore cars to move tons of rock. (Courtesy of History Colorado, CHS.X7726.)

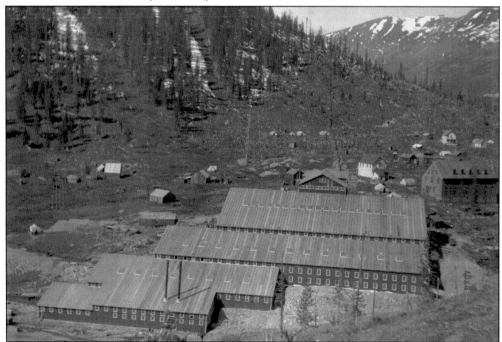

GOLD PRINCE MILL, 1906. When finished in 1906, the Gold Prince Mill was the largest mill in Colorado at the time. Otto Mears extended his Silverton Northern Railroad from Eureka to Animas Forks to serve it. The boardinghouse is to the right of the mill.

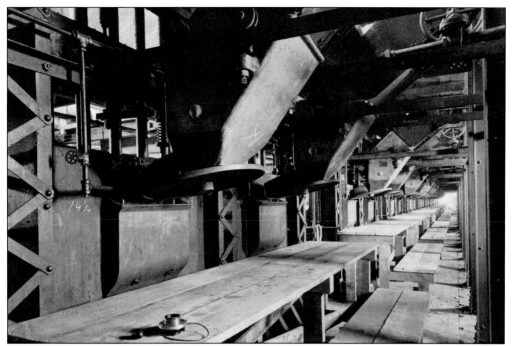

ORE FEEDERS, 1907. These Challenge ore feeders in the Gold Prince Mill were used to automatically feed ore into the stamp batteries, thus eliminating hand-feeding that was used in older mills. (Courtesy of History Colorado, CHS.X7724.)

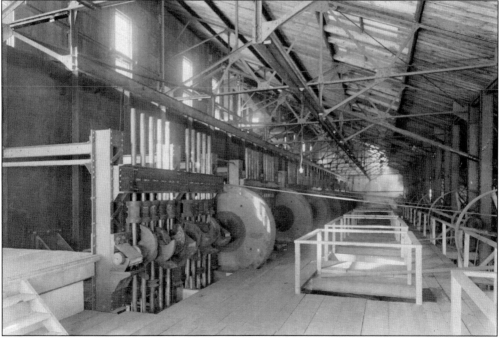

STAMP BATTERY, 1907. This view shows the upper part of a series of the 10-stamp batteries on the left in the Gold Prince Mill. Heavy metal stamps at the bottom of the rods are lifted and dropped by rotating cams. The falling stamps then crush the ore. (Courtesy of History Colorado, CHS.X7715.)

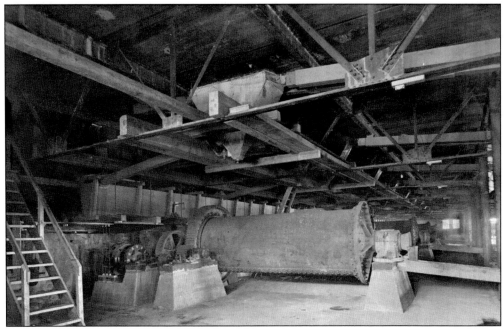

TUBE MILLS, 1907. The ore from the stamp batteries was ground even finer in this series of tube mills in the Gold Prince Mill. The mill closed in 1910, and four of these tube mills were used in the second Sunnyside Mill in Eureka, built in 1917. Note the use of steel ceiling-support girders, which was unusual. (Courtesy of History Colorado, CHS.X7710.)

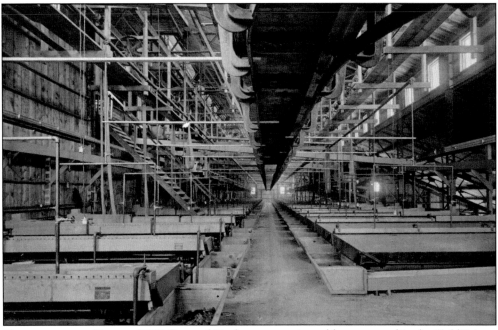

CONCENTRATING TABLES, 1907. Rows of Card concentrating tables were used in the Gold Prince Mill to separate heavy mineral particles from the lighter waste particles. This was accomplished by the use of longitudinal riffles and a horizontal back-and-forth motion that allowed the heavier particles to be carried off the end of the table. (Courtesy of History Colorado, CHS.X7714.)

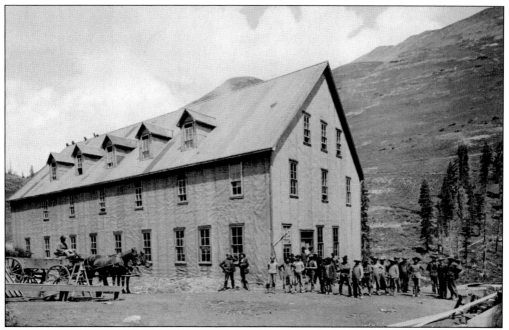

GOLD PRINCE BOARDINGHOUSE. Next to the Gold Prince Mill was the three-story boardinghouse that lodged the men who worked in the mill. Here, the boardinghouse appears to be almost completely built, about 1905–1906. The outside of the structure is covered with tar paper. (Courtesy of History Colorado.)

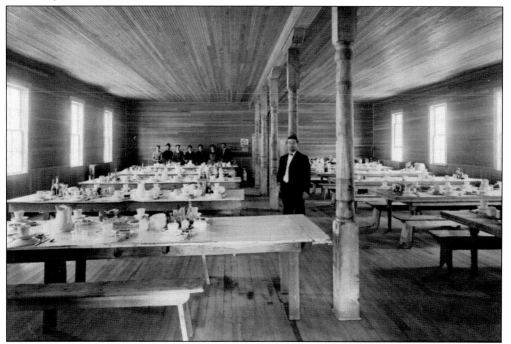

GOLD PRINCE DINING HALL. The dining hall at the Gold Prince Mill consisted of a series of tables and benches, here set for the workers about 1907. A group of men and women stand in the back. One of the women is wearing an apron and may be the cook. (Courtesy of History Colorado.)

MINE BICYCLE, 1914. Bicycles that were modified to run on the mine rail were sometimes used by mine supervisors to get around inside the mine. These budding miners are testing out one at the Frisco Mine near Animas Forks. From left to right are a Mrs. Henson, Fred Henson, and Dan McNaughton Jr.

KLONDIKE MINE. Dick Carlson had his photograph taken in August 1913 at the entrance to the Klondike Tunnel, which was located in Burns Gulch. Mine track is leading into the timbered portal.

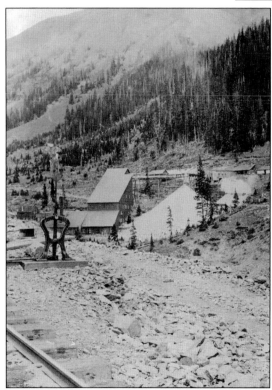

SILVER WING MILL, C. 1906. The Silver Wing Mill was located along the Silverton Northern Railroad tracks between Eureka and Animas Forks. This 150-ton-per-day mill was built in the 1890s and operated into the 1950s. A log cabin in Burns Gulch is visible at left, above the harp switch.

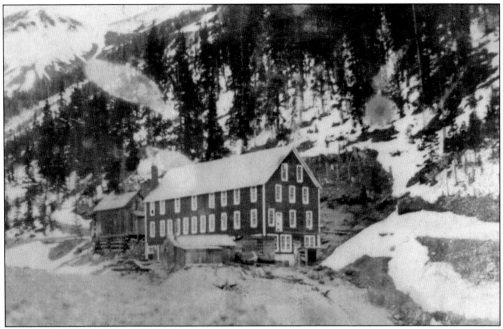

TOM MOORE BOARDINGHOUSE, C. 1902–1908. The Tom Moore boardinghouse was located between Eureka and Animas Forks in the Animas Canyon. In December 1908, a "monster snowslide" crushed part of the Tom Moore boardinghouse and killed one man. This boardinghouse was demolished by a second avalanche on January 5, 1910, and never rebuilt.

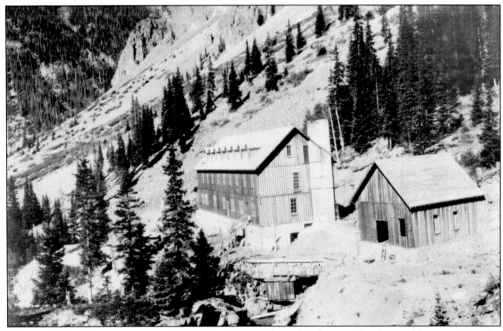

MARTIN MINE BOARDINGHOUSE. The Martin Mine boardinghouse, also located between Eureka and Animas Forks, was built in 1929. It is still standing and is one of the best preserved mine boardinghouses in the San Juan Mountains. The structure currently has been restored and operates as a bed-and-breakfast called the Eureka Lodge.

Eight

EUREKA

Eureka began with one cabin built by three prospectors in 1873. The history of Eureka was closely entwined with that of the Sunnyside Mine, located three miles northwest of and 2,000 feet above it. Eureka was a subdued town compared to others in the San Juans, and in the late 1870s, it had about 20 houses. In the mid-1880s, it had a population of 150 and boasted a post office, notary public, restaurant, butcher shop, livery stables, and two saloons.

The Sunnyside Mine was discovered near Lake Emma in 1873 by Ruben J. McNutt and George Howard. Initially, development of the mine was slow because the rocks were very hard and the elevation of 12,300 feet complicated matters even more.

In addition to the complexity of the Sunnyside ores, which contained gold and silver as well as lead, copper, and zinc, and the large amount of low-grade ores, good recovery of metal values was difficult until the technology to mill these ores had been developed. In 1899, a new mill in Eureka that had better recovery processes was connected to the mine and the old mill by a three-mile-long tramway. Shortly after that, both mills were able to concentrate the ores, and recovery rates increased. In 1910, a larger selective flotation mill that produced a separate lead-zinc concentrate, instead of a total concentrate, started to operate. This new Sunnyside mill was the first in the country to employ this process.

In 1886, the Silverton Northern Railroad reached Eureka, greatly reducing transportation costs for Sunnyside concentrates. The Sunnyside operated sporadically between 1930 and 1991, when it was closed down. Most of the buildings in Eureka were either sold or relocated to other places in 1948. Today, very little is left of Eureka, except for the town's water tower and the crumbling foundations of the two Sunnyside mills.

See Allan Bird's book *Silverton Gold* for a complete history of the Sunnyside Mine.

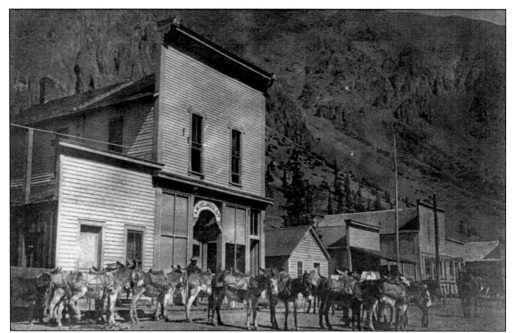

HELMBOLDT STORE, EUREKA. Adoph W. Helmboldt had a store located on the main street in Eureka and sold general merchandise and meat. This image was taken between 1893 and 1902 and is looking toward the north. A string of pack animals is being loaded with supplies destined probably for the Sunnyside Mine.

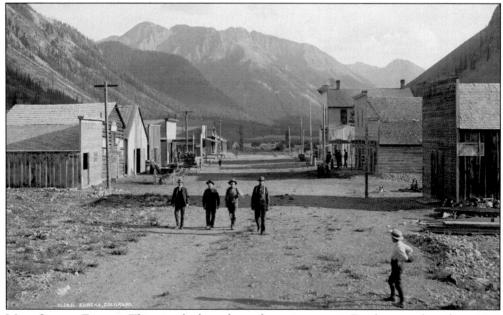

MAIN STREET, EUREKA. This view looking down the main street in Eureka was taken about 1890 and shows four gentlemen walking up the street with some children playing in the background. On the left side of the street, a stable and a saloon can be seen. Across the street is a restaurant and the Miner's Home, which was actually another saloon. (Photograph by William Henry Jackson; courtesy of the Library of Congress.)

RUBEN MCNUTT AND GEORGE HOWARD. The Sunnyside Mine was discovered on August 18, 1873, by George Howard (left) and Ruben J. McNutt (below). They were prospecting on the north side of Hurricane Peak across the ridge from Lake Emma. They got caught in a thunderstorm and decided to cross the ridge over to the sunny side of the mountain. Just north of Lake Emma, they discovered a large quartz outcrop. The two men had agreed to stake separate claims, so McNutt staked the Sunny Side (later the Sunnyside) and the George Washington, and Howard staked the No Name and the Belle Creole (Left, photograph by A.E. Rinehart; below, photograph by Charles Bohm.)

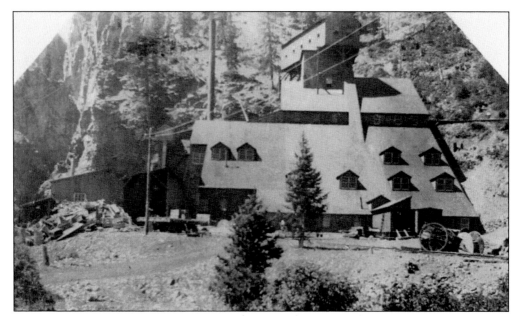

JOHN TERRY'S FIRST EUREKA MILL. In 1898, John Terry, then owner of most of the Sunnyside, began construction of a new mill in Eureka. The mill had the most modern machinery available to recover gold and started up on January 10, 1899. This view of the mill was taken from near the Animas River looking west, sometime between 1902 and 1908. (Photograph by Mrs. O.M. Huff.)

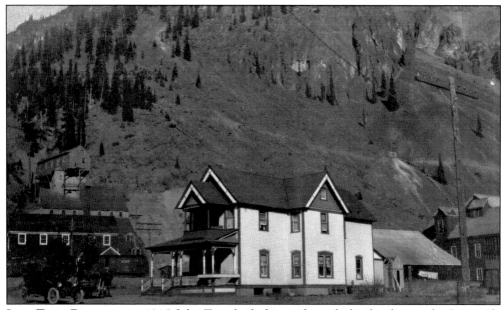

JOHN TERRY RESIDENCE, C. 1915. John Terry built this residence for his family near the Sunnyside mill in Eureka. The first Eureka Mill can be seen on the left in the background. This view is looking northwesterly toward the site of the later mill. Note the three forms of transportation seen in this image: automobile, wagon, and railroad boxcar.

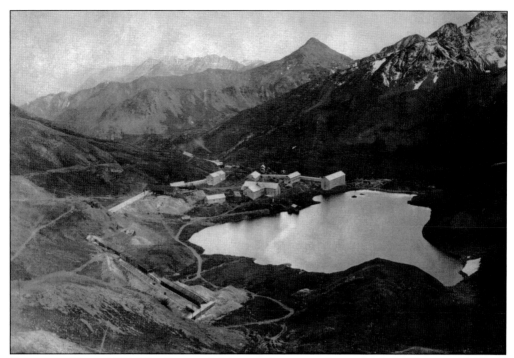

Sunnyside Mine, 1921. The Sunnyside Mine workings were located at Lake Emma, at the head of Eureka Gulch. This image was taken after rebuilding the boardinghouses and related structures following the 1919 fire. The entrance to the No. 1 level of the Sunnyside is in the foreground. The rebuilt boardinghouse is in the center. Sheds cover most of the track and walkway areas between structures and workplaces to eliminate the snow hazard in winter.

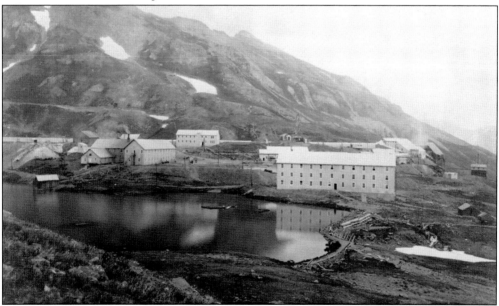

Sunnyside Boardinghouse. This view shows a closer look at the structures at the Sunnyside Mine after being rebuilt following the 1919 fire. The large structure in the center is the boardinghouse that provided housing for the men working at the mine. Lake Emma is in the foreground.

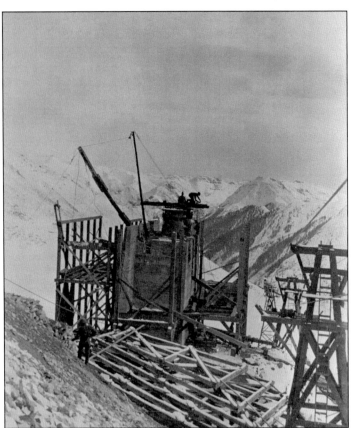

CRUSHING PLANT, 1917. Construction of the crushing plant at the Sunnyside Mine tram terminal at Lake Emma took place in November 1917. A crane is being used to lift the framing into place. The new plant would crush ore from the mine to a diameter of 2.5 inches before being transported to the mill in Eureka.

UPPER END SUNNYSIDE TRAMWAY. Crushed ore from the mine was loaded into tram buckets to be sent to the mill in Eureka for further processing. In this view, empty buckets waiting to be loaded can be seen on the left. The man on the right is positioning a loaded bucket to be sent to Eureka.

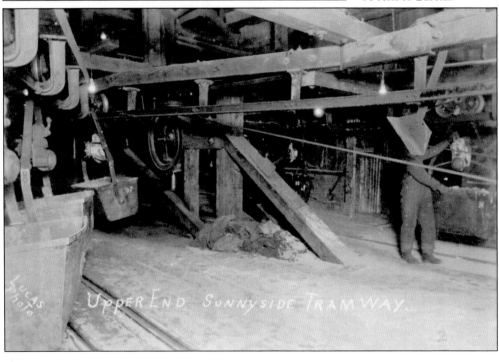

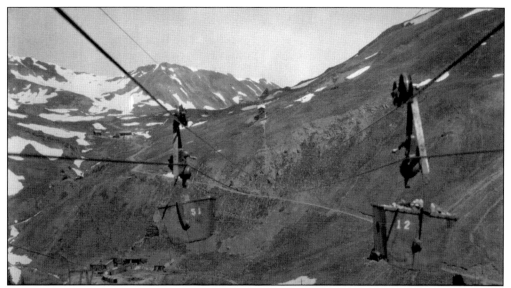

SUNNYSIDE TRAM, C. 1925. The Sunnyside tram was 3.5 miles long and connected the mine with Eureka. In this view, the mine is located over the ridge in the distance. Bucket 12 at right is loaded, whereas bucket 51 is empty. The top cable is stationary and remains taut. The lower strand is the traction wire rope onto which the bucket's bail (called the "grip") clamps and propels the bucket.

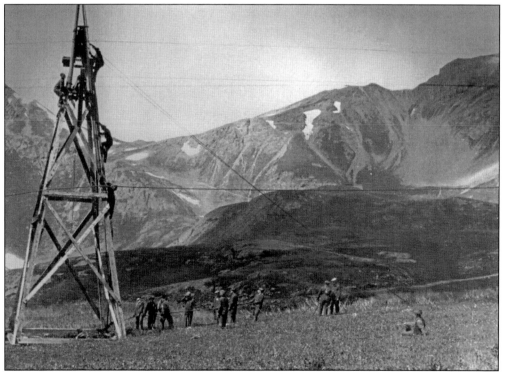

REPAIR CREW, 1927. Tramways were in need of constant maintenance and repair. In addition to everyday wear and tear, tram towers were often damaged by snowslides. This crew appears to be replacing the cable on the Sunnyside Mine tramway.

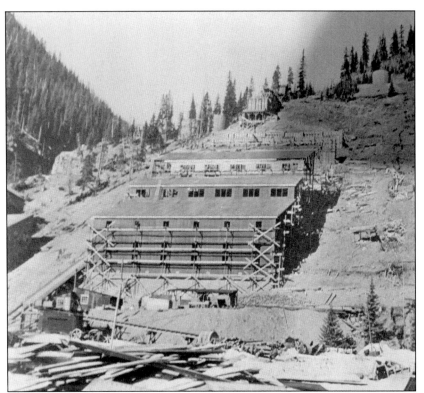

MILL CONSTRUCTION. In 1917, the US Smelting and Refining Company took control over the Sunnyside Mine and began building a new, state-of-the-art, 500-ton-per-day selective-flotation mill at Eureka. This new mill was located next to Terry's mill. These two images show the mill under construction. The above image was probably taken in July 1917 and the image at right on November 10, 1917. In this mill, a new process could selectively separate the lead from the zinc using flotation. This was important, since by this time, the Sunnyside had become essentially a lead-zinc mine. (Both, photograph by Bruce Marquand.)

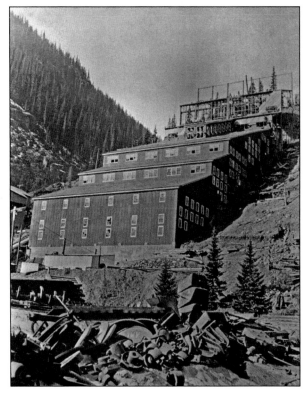

TRANSFORMER HOUSE. This view taken on January 1, 1918, is of the Sunnyside transformer house under construction in Eureka. There is scaffolding around the building, and the roof is framed but not covered. By this time, the second mill, seen in the background, had been completed. (Photograph by Bruce Marquand.)

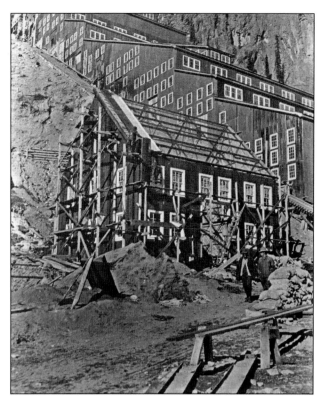

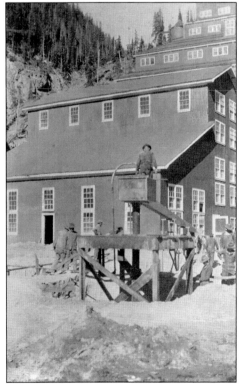

SECOND EUREKA MILL. This view, probably taken in 1918, is of the lower end of the new Sunnyside Mill at Eureka. The section of the mill in the foreground contained the filter plant. The boxed pump standpipe and elevated tank are in the foreground, with a man standing inside the tank. (Photograph by Bruce Marquand.)

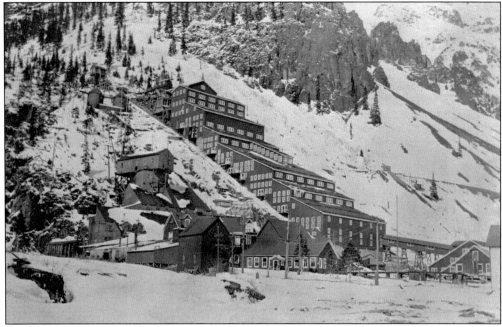

SUNNYSIDE MILLS. This view, probably taken in 1918, shows the difference in size between the old Terry mill on the left and the recently completed second mill on the right. When built, Terry's mill had a capacity of 125 tons per day, whereas the US Smelting Mill had an initial capacity of 500 tons per day.

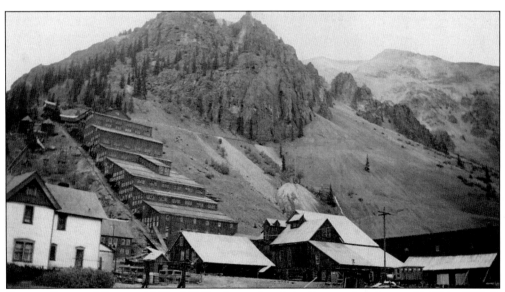

SECOND EUREKA MILL, C. 1930s. US Smelting closed the Sunnyside Mine and Mill in 1930. It was reopened for two years in 1937. Judge Terry's old house is on the left. The railbus in the lower right, the *Casey Jones*, was built by the mine in 1915 to provide fast transportation of injured men to the hospital in Silverton. The San Juan County Historical Society currently owns the *Casey Jones*, and it is still operated for special occasions.

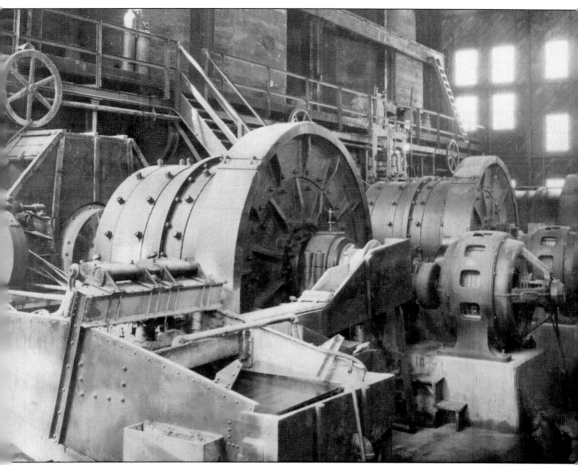

MARCY BALL MILLS, 1919. This view of the interior of the second Sunnyside Mill at Eureka shows three of the eight-by-six-foot Marcy ball mills that were built by the Mine and Smelter Supply Company of Denver in 1917. Ore was crushed at the mineshaft by three No. 6 Gates gyratory crushers before being loaded onto a 16,000-foot-long Trenton Iron Works aerial tramway for delivery to the three concrete ore bins at the mill. The Marcy Mills took the 2.5-inch crushed ore delivered from the mine, mixed it with water, and ground it to .05 of an inch. Normally, only two ball mills were operated at any time, and they could process 600 to 750 tons per day. However, in 1928, by using all three ball mills, the Sunnyside mill reached 1,000-ton capacity and was the largest flotation mill in Colorado. In the foreground can be seen the bottom section of a 6-by-18.5-foot Dorr Model C Heavy rake classifier used to separate coarse material from the ball-mill discharge for regrinding. Photographs on the next four pages also show the interior of the second Sunnyside Mill at Eureka. (Photograph by Bruce Marquand.)

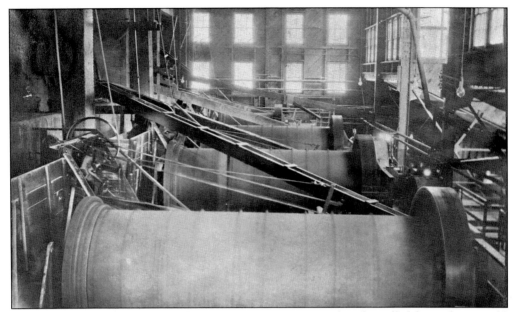

TUBE MILLS, 1919. These 5-by-14-foot Denver Engineering Works tube mills (above photograph) were used for the final fine grinding of ore prior to flotation. These tube mills were originally built in 1906 for the Gold Prince Mill in Animas Forks. In the background can be seen a fourth five-by-eight-foot ball-tube mill, which was shortened from another of the 14-foot mills for use with conventional steel grinding balls. Instead of using grinding balls in the three longer tube mills, chunks of pink rhodonite waste rock from the mine were used. Rhodonite is a very hard manganese silicate mineral. These mills could grind the ore finer than flour—fine enough to pass a .005-inch screen. Such fine grinding was necessary for the flotation process. The photograph below shows one of the tube mills at rest. (Both, photograph by Bruce Marquand.)

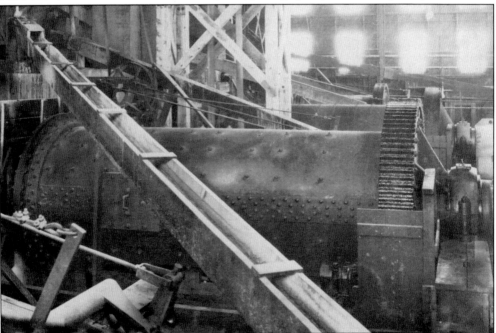

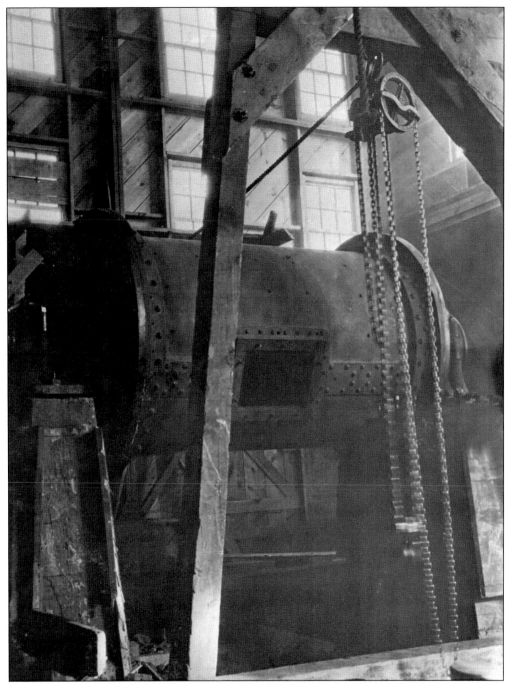

BALL-TUBE MILL, 1919. This is the five-by-eight-foot ball-tube mill located in the second Sunnyside Mill at Eureka that was made by shortening one of the 14-foot tube mills obtained when the Sunnyside company purchased the Gold Prince Mill. Originally built by the Denver Engineering Works in 1906, the tube mill was shortened at the Sunnyside's own machine shop. The idea was to see how well ball milling would work. The man-door cover on the side of the ball-tube mill is open. (Photograph by Bruce Marquand.)

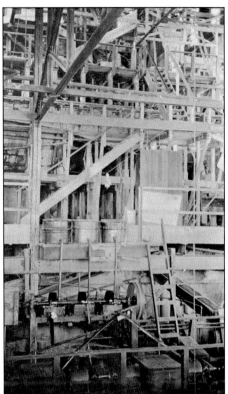

LEAD FLOTATION CELLS, 1919. The upper portion of the photograph is looking up at the 10-cell bank of patented mineral-separation flotation cells used to separate the lead concentrate. In the center are three reagent drums and feeders for metering flotation reagents to the zinc cells. Pine oil, coal tar, and potassium were used as xanathate flotation chemicals. The pine oil was the frother and made the bubbles. Coal tar made the bubbles tougher. The xanathate collector caused the zinc particles to adhere to the surface of the bubbles and float to the top of the cell (tank) where they could be skimmed off like cream. (Photograph by Bruce Marquand.)

MINERAL SEPARATION FLOTATION MACHINE, 1919. This long bank of 24-inch standard mineral-separation patented flotation cells produced the zinc concentrate for which the Sunnyside mill was famous. Because there was more zinc in the ore than lead, there were twice as many zinc cells installed as lead cells. The cells are in operation, and the flat belt-driven paddles used to skim off the zinc-laden flotation bubbles can be seen spinning at the lip of the redwood tanks. (Photograph by Bruce Marquand.)

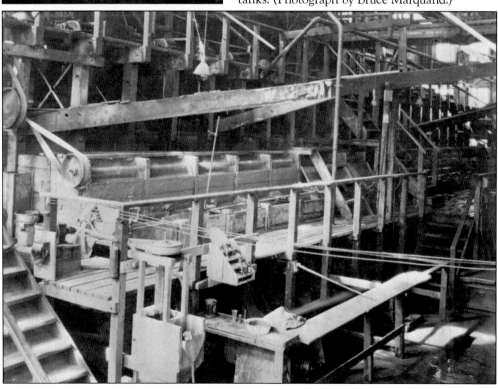

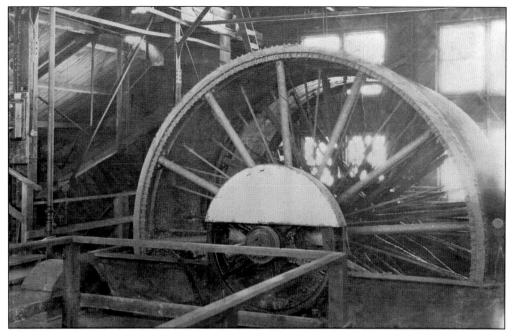

VACUUM FILTER, 1919. This is one of three 12-foot diameter by 5-foot long Portland vacuum filters used for final dewatering of the zinc flotation concentrate. Covered in canvas and connected by the numerous vacuum pipes inside the drum, the filter literally sucked the moisture out of the watery concentrates. The concentrates were loaded into narrow-gauge boxcars on the Silverton Northern Railroad for shipment to a smelter. (Photograph by Bruce Marquand.)

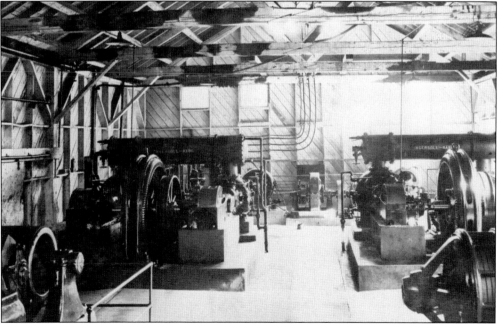

INGERSOLL-RAND AIR COMPRESSORS, 1919. Seen here are two Ingersoll-Rand "Imperial Type 10" air compressors probably being used instead as vacuum pumps for the Portland vacuum filters seen above. (Photograph by Bruce Marquand.)

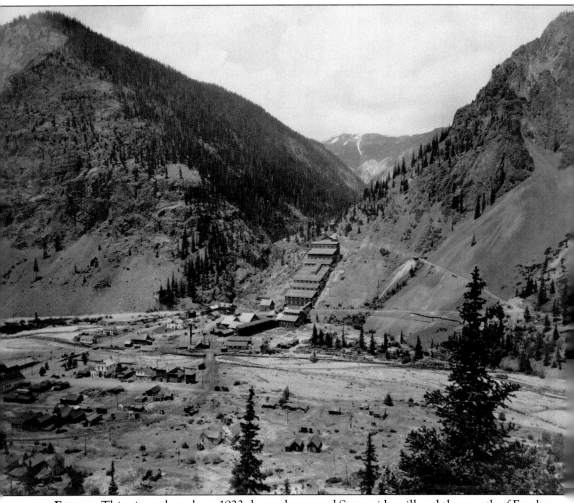

EUREKA. This view taken about 1923 shows the second Sunnyside mill and the mouth of Eureka Gulch, as well as much of the business district and cabins at the north end of the settlement. The Sunnyside mine is located 3.5 miles up at the head of Eureka Gulch. By this time, the mill that John Terry built was no longer standing. (Photograph by Bruce Marquand.)

TEAM HAULING BOILER TANK, C. 1923. This team is hauling a boiler tank from Eureka to the Sunnyside Mine at Lake Emma. Six animals are up front pulling the boiler, and two are behind pushing. This team may have been one owned by the Shaw brothers, George and Ernest, who were famous for going to the North Pole with Robert Peary.

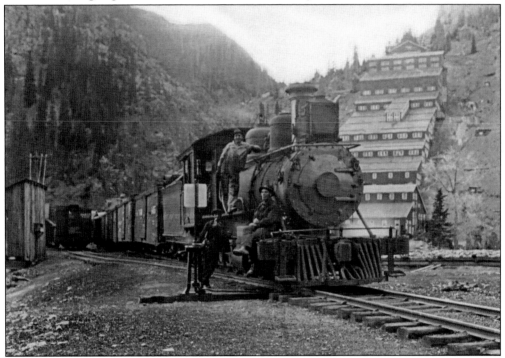

SILVERTON NORTHERN RAILROAD, EUREKA. Silverton Northern Engine No. 34 sits in front of the second Sunnyside mill in Eureka. Eureka Gulch is in the background. The string of boxcars was used to carry concentrate from the Sunnyside Mill down to Silverton, where they were transferred to the Denver & Rio Grande Railroad bound for the smelters.

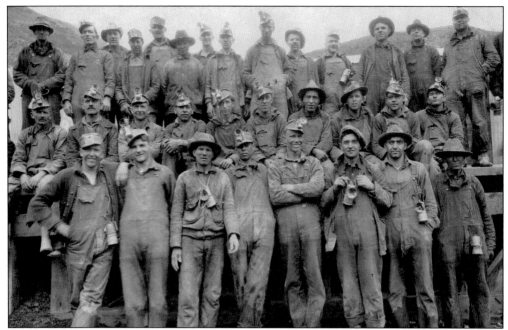

SUNNYSIDE MINERS. These miners were working at the Sunnyside Mine on July 12, 1929, when this group photograph was taken. Instead of candles, carbide lamps were used at this time to provide lighting underground. Miners either used four-hour cap lamps or eight-hour hand lamps, as seen in this image. (Photograph by Joe Navalesi.)

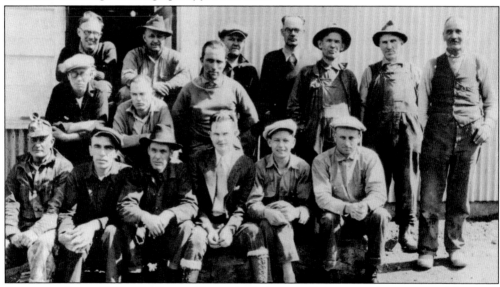

SUNNYSIDE STAFF, 1928. The Sunnyside required a large staff to oversee the running of the mine. The staff included, from left to right, (first row) Guy Gardner (shifter), Mike Musick (shifter), Tom Davis (bull gang boss), Dr. Hutchins (doctor), Fenrick Sutherland (commissary), and A.C. Gabbert (shifter); (second row) Robert Hook (bookkeeper), Clifford Parmer (bookkeeper), and George Hodges (engineer); (third row) J.T. Franks (surveyor, engineer), Wilfred Fleming (superintendent, 1922–1931), Dick Cram (warehouse), Fred Melzer (engineer), Sam Usnick (shifter), Martin Loftus (shifter), and Ed Heuter (shifter). (Courtesy of the Denver Public Library.)

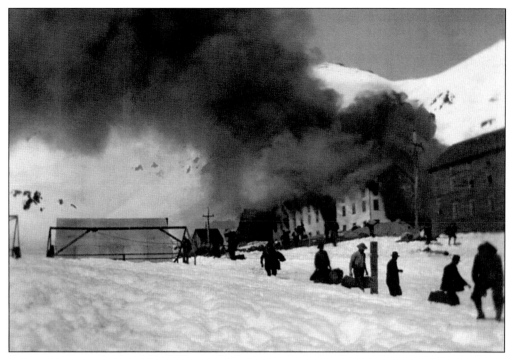

SUNNYSIDE FIRE. On April 24, 1919, a fire broke out in the barbershop in the commissary building; all the buildings burned except the tram station, machine shop, and blacksmith shop. Among the structures lost were two bunkhouses and a boardinghouse. Men are seen here packing their belongings over the snow. Total loss to the mine was $400,000, but that figure does not include the miners' possessions lost in the fire.

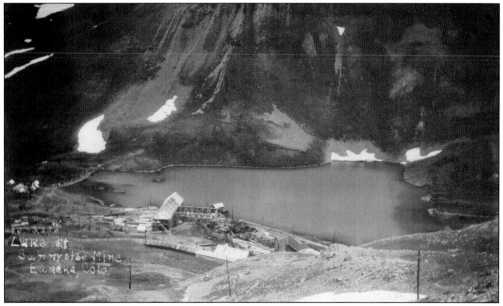

AFTER THE FIRE. US Smelting began rebuilding the structures at Lake Emma immediately after the fire. This image shows the one of the buildings on Lake Emma being constructed. The snowshed for the entrance to the mine is located in front of the new structure.

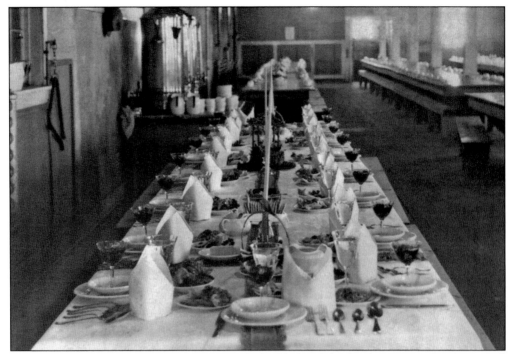

SUNNYSIDE MINE DINING HALL. Meals were the highlight of the day for miners. The dining hall in the boardinghouse consisted of a series of long tables and benches. Polished coffee urns are on the left, and the more plainly set tables for the workingmen are at the right. This photograph shows a special staff dinner in 1926 for someone's wedding at the Sunnyside Mine. The chef had worked at a large New York hotel and was showing off.

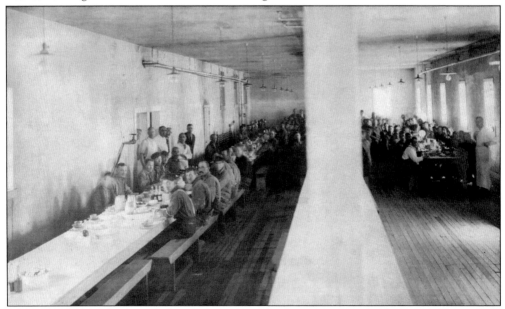

MEAL TIME. This photograph shows miners seated eating a meal in the Sunnyside dining hall. Note the kitchen staff standing near the door on the left. The dining hall was illuminated by electric light bubs hanging from the ceiling. (Courtesy of Benjy Kuehling.)

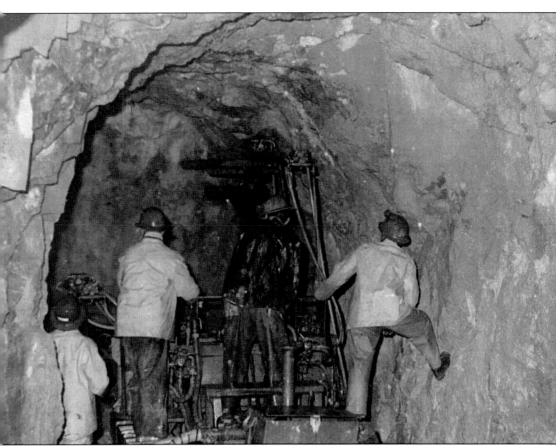

AMERICAN TUNNEL, 1960. In 1959, Standards Metals leased the Sunnyside Mine from US Smelting and began driving a low-level access tunnel to open the mine. The Sunnyside Mine had been closed since the late 1930s. The first phase was to widen the existing Gladstone Tunnel from its original 8-by-10-foot dimension to 11 by 12 feet. The renamed American Tunnel was then extended an additional mile and a 300-foot vertical raise was driven from the tunnel to access the lower workings of the mine. This view shows a drill jumbo, mounted on a converted crawler-loader, drilling a burn-cut blasting round at the face of the tunnel. Each round was loaded with 16-inch-long, 1.25-inch-diameter dynamite sticks. The man on the left is Ed Hunter, who was one of the shift bosses. Next to him is Bud Leber. (Courtesy of Ed Hunter.)

BIBLIOGRAPHY

Benham, Jack. *Silverton*. Ouray, CO: Bear Creek Publishing Company, 1981.

Bird, Allan G. *Silverton Gold, The Story of Colorado's Largest Gold Mine*. Silverton, CO: self-published, 1986, 1999.

Fetchenhier, Scott. *Ghosts and Gold: The History of the Old Hundred Mine*. Silverton, CO: self-published, 1999.

Jones, William R. *History of Mining and Milling Practices and Production in San Juan County Colorado, 1871–1991*. Washington, DC: Chapter C of US Geological Survey Professional Paper 1651, 2007.

Marshall, John, and Zeke Zanoni. *Mining the Hard Rock in the Silverton San Juans: A Sense of Place, A Sense of Time*. Silverton, CO: Simpler Way Book Company, 1996.

Nossaman, Allen. *Many More Mountains, Volumes 1, 2, and 3*. Denver, CO: Sundance Publications Limited, 1989, 1993, and 1998.

Peterson, Freda Carley. *The Story of Hillside Cemetery, Silverton, San Juan County, Colorado, Volume 1 and 2*. Oklahoma City, OK: self-published, 1996 and 1997.

Rich, Beverly, and Casey Carroll. *Walking Silverton: History, Sights, and Stories*. Durango, CO: Durango Herald Small Press, 2014.

Sloan, Robert, and Carl A. Skowronski. *The Rainbow Route: An Illustrated History of the Silverton Railroad*. Silverton, CO: Sundance Publications Limited, 1975.

Smith, Duane A. *A Brief History of Silverton*. Montrose, CO: Western Reflections Publishing Company, 2004.

———. *Song of the Hammer and Drill, The Colorado San Juans, 1860–1914*. Golden, CO: Colorado School of Mines Press, 1982.

Smith, P. David. *Mountains of Silver: Life in Colorado's Red Mountain Mining District*. Montrose, CO: Western Reflections Publishing Company, 2000.

———. *Exploring the Historic San Juan Triangle*. Ridgeway, CO: Wayfinder Press, 2004.

Twitty, Eric. *Basins of Silver: The Story of Silverton, Colorado's Las Animas Mining District*. Lake City, CO: Western Reflections Publishing Company, 2009.

Vendl, Mark A., Duane A. Smith, and Karen A. Vendl. *My Home at Present, Life in the Mine Boardinghouses in the San Juan Mountains, Colorado*. Lake City, CO: Western Reflections Publishing Company, 2013.

THE SAN JUAN COUNTY HISTORICAL SOCIETY

The San Juan County Historical Society (SJCHS) was established in 1964 as a nonprofit 501(c) (3) Colorado Corporation for preserving the history of San Juan County, Colorado.

Mining heritage has been the heart of San Juan County's development. Many service industries were instrumental in the success of the mining industry, including the railroad for transportation of the ores, Otto Mears's toll-road system, the mining of precious metals from numerous mines, the mills and smelters, boardinghouses, and the support towns that followed the big strikes, which provided employment, supplies, housing, cultural opportunities, and entertainment.

The Town of Silverton, the Durango & Silverton Narrow Gauge Railroad, and the Mayflower Mill have each been designated a National Historical Landmark. The Old Hundred Boardinghouse, owned by SJCHS, is on the Colorado list of Historic Places. Properties owned by the San Juan Historical Society include the Mayflower Mill, the Little Nation Mill (located at Howardsville), the *Silverton Standard and the Miner* newspaper, the Engine House, and the Silverton Power Station.

The historical society operates the Mining Heritage Center, the 1902 County Jail Museum in Silverton, the Mayflower Mill Tour, the Allen Nossaman Memorial Archive, the Silverton Power Station, and the *Silverton Standard and the Miner* newspaper.

Work has begun on the Silverton Railroad Historical Park, located between the Silverton Northern Engine House and the Silverton Depot. Another railroad effort is focused on the reconstruction of the Silverton Northern Railroad. The goal is to have tourist excursions from Silverton to Howardsville.

The SJCHS collaborates with the Hillside Cemetery to preserve the stories and dignity of those buried in our cemetery. Additionally, the SJCHS works in partnership to stabilize and preserve buildings such as the Old Hundred Boardinghouse and other historic structures.

The SJCHS has received numerous awards from History Colorado and has received two National Honor Awards from the National Trust for Historic Preservation for their work.

Partnerships and collaborations with Colorado, national historical organizations, and private foundations help to fund some of the major renovation projects. However, many projects and daily operations are funded by visitor fees, donations, and San Juan County Historical Society membership subscriptions.

DISCOVER THOUSANDS OF LOCAL HISTORY BOOKS FEATURING MILLIONS OF VINTAGE IMAGES

Arcadia Publishing, the leading local history publisher in the United States, is committed to making history accessible and meaningful through publishing books that celebrate and preserve the heritage of America's people and places.

Find more books like this at
www.arcadiapublishing.com

Search for your hometown history, your old stomping grounds, and even your favorite sports team.

Silverton is located in the heart of the San Juan Mountains, which have been described by H.H. Bancroft as "the wildest and most inaccessible region of Colorado, if not North America." The region has a long and colorful mining history, dating back to the Spanish exploration of the area in the 18th century. For the past 250 years, men have sought gold and silver in these mountains. However, full-scale mining did not begin until the 1870s, and for more than a century, mining was the lifeblood of Silverton and the surrounding area. The San Juan Mountains have been called one of the four great mining areas of Colorado, in a state known for its mining heritage. This is not only the story of the mines but also of the men and women who worked and lived in these rugged mountains.

Mining historians and authors Karen A. Vendl and Mark A. Vendl are retired geologists with a lifelong interest in Colorado history. The San Juan County Historical Society provided the majority of the images for this book. Duane A. Smith is a retired professor of history at Fort Lewis College and the author of numerous books on Colorado and mining history.

The Images of America series celebrates the history of neighborhoods, towns, and cities across the country. Using archival photographs, each title presents the distinctive stories from the past that shape the character of the community today. Arcadia is proud to play a part in the preservation of local heritage, making history available to all.

ARCADIA
PUBLISHING

www.arcadiapublishing.com

MADE IN THE USA

ISBN-13 978-1-4671-3286-2 $24.99
ISBN-10 1-4671-3286-1

52499

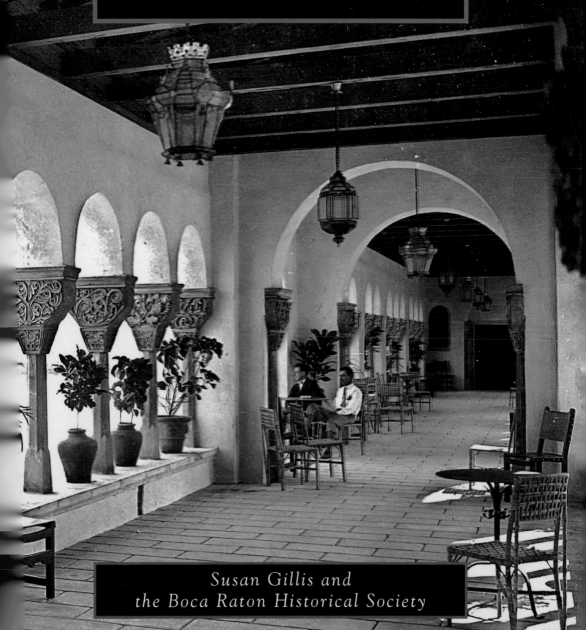

IMAGES *of* America

BOOMTIME BOCA
Boca Raton in the 1920s

Susan Gillis and
the Boca Raton Historical Society